DATE LOANED

AUSTRIA'S EXPRESSIONISM

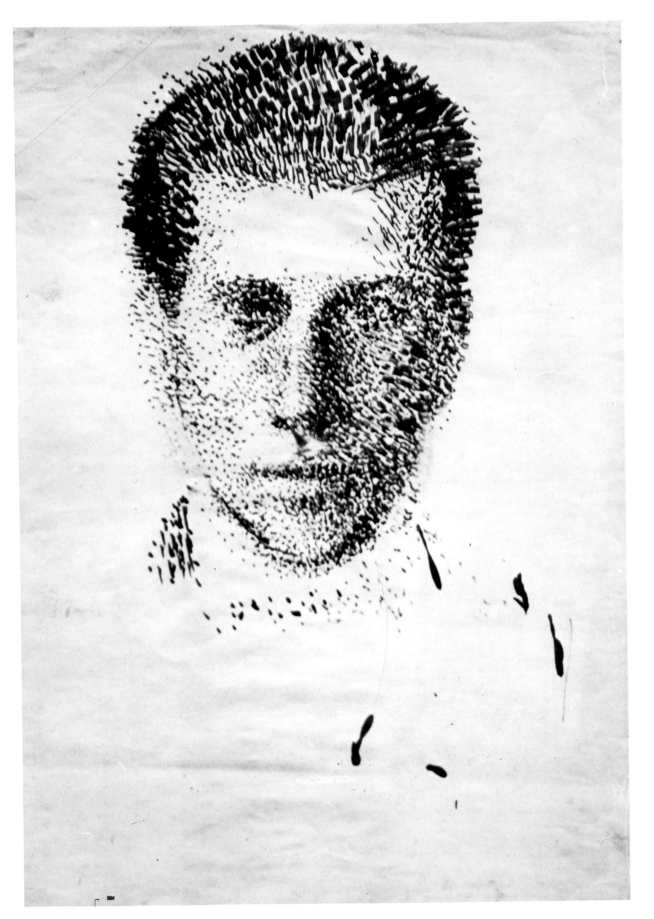

Figure 1 **Richard Gerstl** Self-Portrait. Ca. 1906.

Jane Kallir

AUSTRIA'S EXPRESSIONISM

Galerie St. Etienne/Rizzoli, New York

Exhibition dates:
April 21–May 30, 1981

Galerie St. Etienne
24 West 57th Street
New York, New York 10019

Published in 1981 by Galerie St. Etienne/Rizzoli International Publications, Inc.

ISBN: 0-8478-0389-9

LC: 81-51101

Designed by Gary Cosimini

Printed by Rapoport Printing Corp., New York

Photographs by Eric Pollitzer: Cover; Plates 1, 2, 3, 4, 5, 7, 11, 14, 15, 18, 20, 21, 23, 28, 29, 30; Figures 2, 7, 9, 10, 14, 27, 34, 41, 42, 45, 46, 48, 49, 55, 56.

Cover **Egon Schiele** Self-Portrait. 1912.

CONTENTS

PREFACE

Austria's Expressionism has long been considered, when it was considered at all, a minor offshoot of its German counterpart. Though it was less easy to ignore German Expressionism, the modern French tradition was frequently judged to be of more immediate relevance. Thus, Austrian art became a poor cousin twice removed from the sphere of world cultural events.

It is not difficult, when one looks back on the history of the 20th century, to understand how this happened. The glorious empire that was Austria-Hungary did not survive the first world war. After the collapse of the Monarchy in 1918, the nation entered a period of eclipse that has yet to end. Germany became the dominant force in German-speaking Europe, and remains so to this day. However, two world wars have not made Americans well-disposed toward things Germanic. As one critic put it: "In anyone accustomed to looking at predominantly French or French-influenced art, [German Expressionism] will provoke varying degrees of visual indigestion."[1]

Further obstacles to the appreciation of Austrian art were created by the fluid boundaries that characterized its study and practice. Artists frequently changed domiciles, so that in some instances it is hard to decide just what qualifies as Austrian art. The Romantics who arrived from the north to study in Vienna in the first decade of the 19th century stayed no more than a few years, yet they left a residue that was to permeate the century. On the other hand, many Austrians, sensing more opportunities to exhibit and sell their work, moved to Germany.

A great deal of interchange took place between Vienna and Munich, and it was not uncommon for artists, especially those from western Austria, to choose the art academy in the Bavarian capital over that in their native land. Travel was considered both a supplement to an artist's basic training and a potential source of inspiration. Trips to Italy were especially popular, and Paris inevitably lured Austrian painters. Views of more exotic places also kindled the Austrian imagination, prompting at least one painter to journey around the world in search of the unusual. Nonetheless, while Austrians have not always stayed put in Austria, their art has managed to maintain a national character that transforms foreign influences.

Austria's Expressionism evolved simultaneously with Expressionism in Germany, and was to some extent conditioned by related 19th century cultural trends. However, it was distinct from and largely independent of the German movement. A difference in approach may be perceived already in 19th century Austrian art, and the growth of 20th century Expressionism must be traced back to the 19th century to be understood within its national artistic context. In so doing, this survey does not purport to be complete. Rather, ancillary creative impulses are summarized to provide a cohesive overview. The flowering of Austrian culture, first in the Secession and the Wiener Werkstätte, later in Expressionism, is thereby seen as a coherent aesthetic development.

It is always difficult, in such a study, to determine how much prior knowledge may be assumed on the part of the reader. Conversely, there also is a desire to provide more specialized material for those already well-versed in the field. The basic text straddles the line between these two positions, attempting to be both accessible to the novice and interesting to the expert. For those who require additional background information or elaborations of detail, supplemental material has been provided in the footnotes.

To the many who have helped make this book possible, heartfelt thanks are extended: to Hildegard Bachert for her painstaking research in compiling the list of publications; to Fanny Kallir and Vita Maria Künstler for their patience in recounting old memories that became valuable background information; and to Sally Gately Shafto for her work on the list of exhibitions. Appreciation is also expressed to the museums and collectors who made photographs available: the Museum of Fine Arts in Boston; Mr. and Mrs. Herman Elkon; Viktor Fogarassy; the Fogg Art Museum at Harvard University; the Estate of Otto Kallir; Rudolf Kallir; the Minneapolis Institute of Arts; the Solomon R. Guggenheim Museum, Metropolitan Museum of Art and Museum of Modern Art in New York; the Smith College Museum of Art in Northampton, Massachusetts; the Allen Memorial Art Museum at Oberlin College; Alice Steiner; the Graphische Sammlung Albertina, Museum moderner Kunst and Österreichische Galerie in Vienna; the Phillips Collection in Washington, D.C.; David Morgan Yerzy, and numerous private collectors who prefer to remain anonymous.

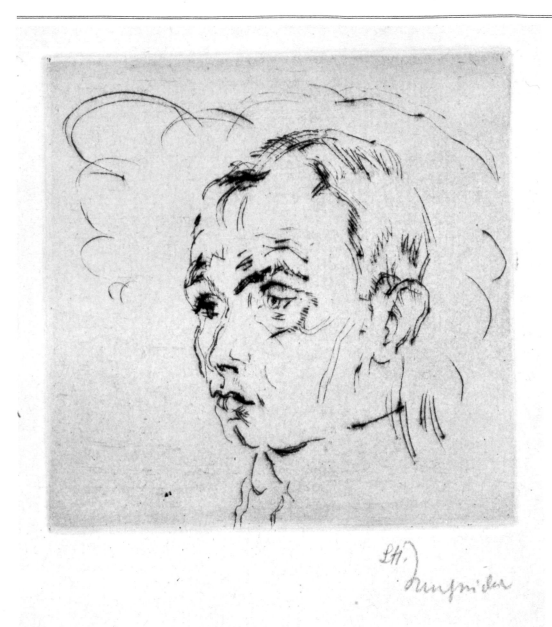

Figure 2 **Ludwig Heinrich Jungnickel** Portrait of Otto Kallir. Ca. 1920.

Introduction
ONE MAN'S VISION

The purpose of this book is twofold. It serves as part of a living memorial to Otto Kallir (1894-1978), who more than anyone is responsible for introducing Austrian art to the United States. But, more important, it is a tribute to that art itself, to which he devoted his entire life and to which all his achievements were subordinate. A brief biography of Kallir is here presented in tandem with the discussion of Austrian art, for the growing American awareness of the latter would be greatly diminished without the contributions of the former. Two appendices provide researchers with the first comprehensive data on the hundreds of publications and exhibitions whereby Kallir achieved his monumental goal.

For Kallir, involvement in the arts was neither the manifestation of his earliest ambition nor the result of a single all-consuming interest. It became, instead, a means by which a multitude of ideas could be expressed. His was a flexible profession which provided outlets for the man as collector, historian, writer, publisher and connoisseur. To call Kallir an art dealer is to perceive only the most superficial aspect of his calling, albeit the one that paid the bills. One must not forget that he would have been far less effective as a dealer had his work not been supported by the breadth of his other interests.

"Hinter der Budl" (behind the counter) was the derogatory Viennese phrase with which his father described Kallir's[2] choice of profession. It had not exactly been Otto's first choice. As a boy, his fascination with burgeoning technological innovations prompted him to seek a career as an engineer. Rising anti-Semitism in the wake of the first world war made him realize that he would never get far in such an Aryan-dominated profession. A nascent interest in art led him, therefore, to join the prestigious gallery Würthle & Sohn in 1919.

From the start, however, he was not content to confine his activities to the buying and selling of art. He himself had studied drawing and painting for a number of years, and after the war resumed his lessons with Johannes Itten, a Swiss who would later acquire an international reputation for the innovative color theories he introduced at the Bauhaus. Earlier, Kallir had apprenticed at the lithographic firm of H. Engel & Sohn, and now he saw an opportunity to combine his interests in art and printing. His first publication was a portfolio of lithographs by his teacher, which was initially distributed by the book dealer Richard Lanyi.[3] It was not long, however, before Kallir had created his own imprint, "Verlag Neuer Graphik," under which he continued to issue books. His preference was for limited editions containing original graphics in sumptuous bindings. These were costly undertakings, and when in 1921 the Rikola Verlag invited him to establish an art division, he willingly accepted the support of the larger concern. Nonetheless, the Verlag Neuer Graphik retained its own identity and even its own offices on the premises of Würthle.

Kallir enjoyed publishing as one enjoys a hobby, but did not see it as a long-term commercial venture. In 1923, he founded the Neue Galerie (Figure 3), where he exhibited many of the same artists whose work he had been publishing: Jungnickel, Klimt, Kubin, Laske and most especially Egon Schiele, to whom he devoted the gallery's first show. He quickly expanded his repertoire to include other contemporary Austrian painters, as well as 19th-century works. Oskar Kokoschka, who returned to Vienna from Dresden in 1924, had a two-part retrospective at the Neue Galerie that year. Kallir went out of his way to assemble costly loan shows, which brought major pieces by Munch, Signac, van Gogh, Corinth and Renoir to Vienna. Some of the shows were so large that he had to join forces with the Hagenbund, an artists' cooperative that had its own exhibition hall, to accommodate them. Such shows established the gallery's reputation, but Kallir had a fondness for offbeat exhibitions as well and was not averse to showing such things as peasant crafts, African art, photographs, historical documents and even cacti.

Kallir's activities in Vienna were so numerous that it is hard to imagine how he had time for them all. Motivated by his passion for the art of Egon Schiele, he began documenting the artist's painted oeuvre, an undertaking that could never have been duplicated later on when most of the work was dispersed. The resultant catalogue raisonné was published in 1930.[4] That same year, Kallir received his doctoral degree in the history of art from the University of Vienna.

Less than a year after founding the Neue Galerie, Kallir created a new publishing concern, the Johannes-Presse, named after his newborn son. In one form or another, this imprint survived for the rest of Kallir's life, although its most significant publications had been issued by 1937. Like those of the Verlag Neuer Graphik, the books were distinguished by high production standards. Subject matter ranged from the poetry of Hugo von Hofmannsthal to an Expressionist drama by Bohuslav Kokoschka, illustrated by his brother Oskar. Kallir also published a suite of etchings by Max Beckmann and several print cycles by Alfred Kubin.

A perceptive eye is an attribute difficult to evaluate. Kallir's instinct for discerning important cultural material was proven when he salvaged the estate of the poet Peter Altenberg in 1927 and installed it in one of the Neue Galerie's back rooms.[5] Judgments of quality and authenticity were important in Kallir's compilation of the Schiele book. But these accomplishments pale beside his ability to recognize and resurrect a totally forgotten painter.

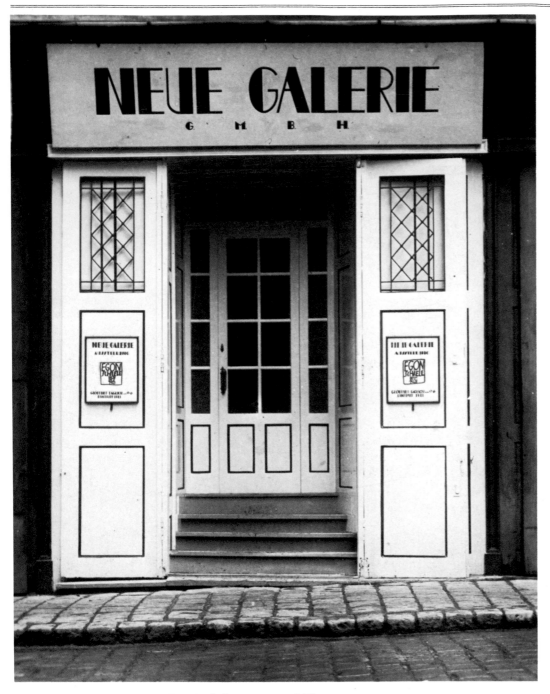

Figure 3 **Entrance to the Neue Galerie** Grünangergasse 1, Vienna.

Figure 4 **The Richard Gerstl Estate Stamp** Affixed by Otto Kallir to the verso of each work and confirmed with his signature.

As Kallir relates the story, ''In . . .1931, a man by the name of Alois Gerstl came to my Vienna Neue Galerie. . . . He told me that his brother, aged twenty-five, had committed suicide in 1908. He had set afire all letters, notes, drawings and paintings in his studio. . . . Only a few works had escaped destruction. The family had stored these . . . in a warehouse, where they had remained to the present day. Alois Gerstl then showed me landscape sketches which aroused my interest. I therefore went with him to the firm of Rosin & Knauer, where I discovered a large number of canvases. . . . Many paintings were damaged by unprofessional handling, the canvas broken or even cut apart. All were soiled and dusty, so that the colors were barely visible. In spite of all this, my impression of this first encounter with the unknown painter Richard Gerstl was an extraordinarily strong one.''[6]

Kallir undertook the enormous task of restoring and cataloguing the artist's estate. All the works were numbered and authenticated with Kallir's signature, as well as a specially designed estate stamp (Figure 4). Then, in September, 1931, Gerstl's work was ready to be shown. The discovery of this lost Expressionist genius attracted international attention, and the exhibition toured Germany the following year. Gerstl was instantly elevated to a place beside Schiele and Kokoschka, a position he later lost but has since regained.[7]

Kallir's artistic insights were extensions of a general facility for evaluating the relative historical significance of varied occurrences. He assumed an observer's attitude to world events, thereby maintaining a distance that allowed him to appreciate with almost prescient understanding the long-range impact of immediate happenings. This awareness fueled his collector's instinct. As an officer in World War I, he brought back more than run-of-the-mill souvenirs. He even tore the page from a hotel register

on which numerous high-ranking military personnel, in town to negotiate the armistice with Italy, had signed their names. Kallir was an avid collector of autographs and historical documents, but always kept a special place in his heart for material having to do with aeronautics. Having witnessed, and to a large extent anticipated, the birth of modern aviation,[8] he assembled not one but two collections of international renown. The first was compiled in Austria; the second, which he put together in the United States, contained such things as fabric from the wings of the Wright Brothers' plane and the license plate from Lindbergh's *Spirit of St. Louis*.

With the advent of National Socialism, history came ever nearer to the center of Kallir's personal life. A restorer who worked for the Neue Galerie, Reinhold Hanisch, kept grumbling about Hitler, and Kallir slowly realized that this man had actually known the "Führer" personally. Hanisch did not mind talking about the days when he and Hitler, both down-and-out artists, had lived together in the flophouses of Vienna. Kallir urged him to write down his recollections, and the resultant essay became one of the first documents to illuminate Hitler's Vienna years.

All the time, the Nazi menace drew closer to Austria, though Kallir never wanted to believe that it would spread to his own country. When Hitler marched in, in 1938, Kallir knew that he and his family would soon have to flee for their lives. Most of the artists to whom he had devoted the past twenty years were branded "degenerate." There could no longer be any possibility of exhibition or open sale of their work (Figure 5). Kallir and his family burned all books and magazines that might be considered incriminating, and also a rather inept Hitler watercolor—another "souvenir" from Hanisch. Hanisch's manuscript itself was hidden in a stove pipe, later to be smuggled out of the country. The Kal-

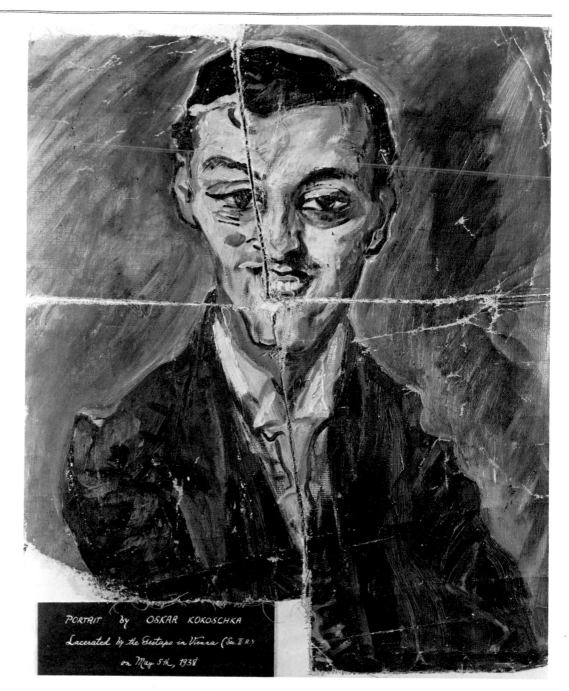

Figure 5 **Oskar Kokoschka** The Publisher Dr. Robert Freund I. Ca. 1914. Slashed by the Gestapo in Vienna on May 5th, 1938.

lir apartment was searched, Kallir himself taken in for questioning on at least one occasion, and it seemed he might be imprisoned at any moment. Hanisch had been arrested immediately after the Nazi takeover, and died in jail several days later.

In May 1938, Kallir officially turned the Neue Galerie over to his long-time assistant, Dr. Vita Maria Künstler, and left with his family for Switzerland.[9] Although his wife and children were allowed to stay in Switzerland, Kallir was not given permission to work there. Thus, later that year, he went alone to Paris to establish a gallery, which he named after Vienna's St. Stephen's Cathedral (Figures 6 and 7), a landmark that stood just a block from the Neue Galerie. Translated into French, this became Galerie St. Etienne.

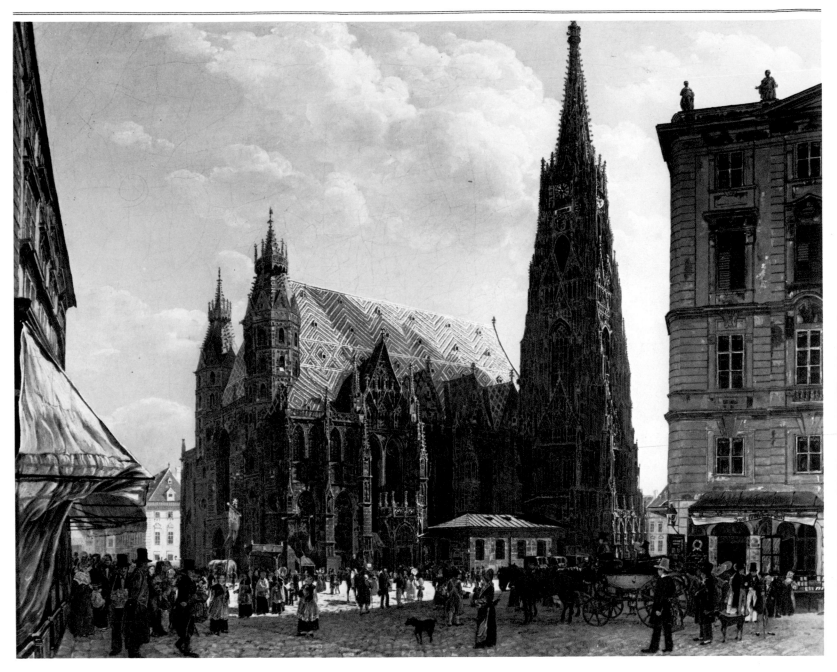

Figure 6 **Rudolf von Alt** St. Stephen's Cathedral. 1832.

However, the Paris gallery was not long-lived, for Kallir had to find a country in which he and his family could be together. In the summer of 1939, the Kallirs sailed for America.

History had finally caught up with Kallir, forcing him to create a whole new life for himself. Americans knew nothing about Austrian art, but he made it his mission to teach them. In November 1939, he opened a New York branch of the Galerie St. Etienne with a show called "Austrian Masters." Though he retained the French name, it soon became clear that he could no more easily return to Paris than he could to Vienna. The New York gallery was now his only gallery, and though for a time after World War II he revived his interest in the Neue Galerie, his most meaningful efforts continued to be based in the United States.

One by one, he gave significant Austrians their first American one-man shows: Oskar Kokoschka in 1940, Schiele and Kubin in 1941, Laske in 1950, and Klimt in 1959. Artists of other nationalities, such as the Germans Erich Heckel (1955) and Paula Modersohn-Becker (1958), and the Swiss Cuno Amiet (1954), were given their initial solo U.S. presentations at his gallery. Searching for an authentic national art in his adopted land, Kallir discovered Anna Mary Robertson (Grandma) Moses, and she, too, was among the many "firsts" presented at the Galerie St. Etienne. The

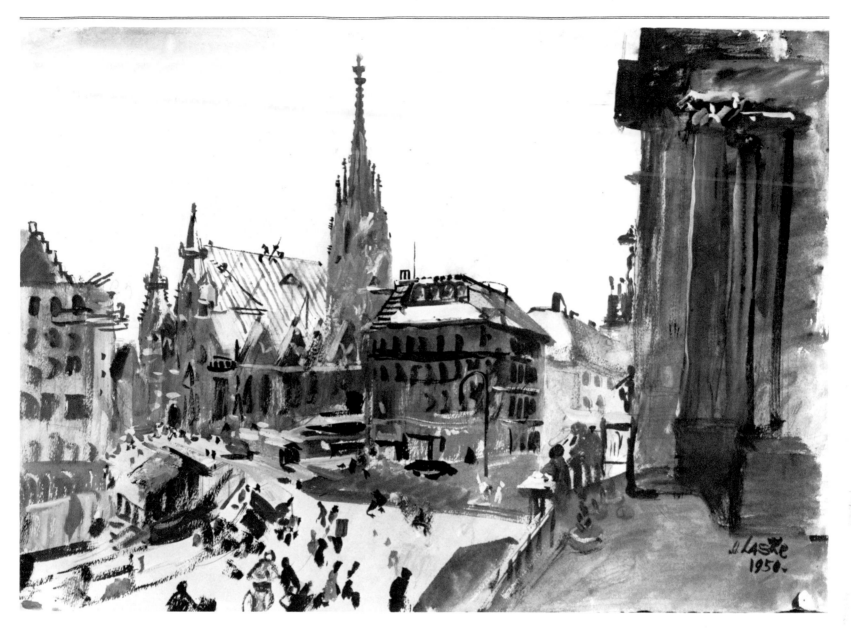

Figure 7 **Oskar Laske** St. Stephen's Cathedral: Post-War Restoration. 1950. In April 1945, half the cathedral had been destroyed by fire.

gallery also became a center for authoritative information on Käthe Kollwitz.

Gradually, the artists Kallir championed began to be recognized in America. This resulted in part from repeated exposure at St. Etienne exhibitions, and in part to Kallir's judicious placing of key pieces in major private and museum collections. The painstaking assistance he gave to young American scholars was crucial in encouraging others to continue the work he had begun. Finally, Kallir felt a need to preserve his lifetime of knowledge, and he began in 1966 by issuing an updated, bilingual version of his Schiele oeuvre catalogue.[10] This was supplemented in 1971 by a catalogue raisonné of Schiele's graphics.[11] In 1973, he gathered all his source material on Richard Gerstl, including first-hand accounts of the artist's life and the original inventory list of the surviving paintings, and published them in the annual bulletin of the Österreichische Galerie.[12]

When Otto Kallir died in 1978, a faddish awareness of *fin de siècle* Vienna was sweeping America. To the extent that he was aware of this trend, he was beset by misgivings about the distortions and biases that popularization inflicted on his nation's cultural history. But, whatever the manner, Austria's art was finally being assimilated into the collective consciousness of America's international aesthetic heritage. Kallir's mission was complete.

Kaiserin Elisabeth.

B.K.W.I.

Figure 8 **Peter Altenberg** Inscribed Postcard Depicting the Eighteen-Year-Old Empress Elisabeth: "You knew nothing and hoped for everything. Later, you knew everything and hoped for nothing."

Background
FROM ROMANTICISM TO RINGSTRASSE

The Vienna Academy of Visual Arts (Akademie der bildenden Künste), like academies in many European capitals, was pivotal both as a stronghold for the most respected artists of the day and as a symbol against which more progressive artists rebelled. At the beginning of the 19th century, Heinrich Friedrich Füger (1751-1818) was the director of the Academy who, to the Romantics, became an emblem of all that was wrong with the educational system. Füger had instituted an instructional program that involved copying antique statuary and stressed drawing over painting. This curriculum, though abhorrent to some, was admired by many for its pseudo-scientific logic. The Vienna Academy acquired an international reputation which rivalled that of its counterpart in Paris.[13] The latter city, in the wake of the French Revolution, was deemed unsafe. The former, on the other hand, was a convenient stopping point for those making artistic pilgrimages to Italy.

So it happened that, in 1805, Franz Pforr (1788-1812) came to the Vienna Academy from Frankfurt, to be joined, one year later, by Friedrich Overbeck (1789-1869) from Lübeck. They did not approve of the methods at the Academy, opposing not just the copying of inanimate objects, but also what they considered the mindless repetition of commonplace truths. "The artist should elevate us through nature to a higher ideal world," wrote Pforr, ". . . but if he works only according to an ideal, without heeding nature, his higher world will lack all charm, and often the loveliest thought can leave us quite cold."[14]

Pforr and Overbeck gathered around them a group of sympathetic artists who, although they had no concrete stylistic program, shared a desire to endow art with religious and moral content. In July of 1809, the group christened themselves the "Brotherhood of St. Luke," and a little less than a year later they left for Rome, where their

peculiar habits and appearance earned them the nickname "Nazarenes."

The departure of the "Brothers" did not, by any means, terminate their influence in Vienna. In 1812, Josef Anton Koch's (1768-1839) arrival in Vienna, after several years in Italy, formed a link with Rome. The Nazarenes sent their completed works back north, and new artists, such as Johann Evangelist Scheffer von Leonhardshoff (1795-1822), Julius Schnorr von Carolsfeld (1794-1872) and Friedrich Olivier (1791-1859), came south to join them. There was always a small nucleus of Romantics in Vienna.

For the Protestant Germans, Rome represented the worldly center of Christian spirituality, a return to Catholic roots. Many of them converted to Catholicism. However, Austria was a strongly Catholic country to begin with. One of the most important theologians at the time, the priest Klemens Maria Hofbauer, led a religious revival which paralleled that of the Romantics. Among his admirers, he counted not only artists like Olivier, but also prominent figures such as the Empress and Prince Metternich.

Nevertheless, the Romantics did not easily win acceptance in Austria's official circles. Josef Sutter (1781-1866), the only original member of the Brotherhood to stay behind in Vienna, complained loudly of persecution on the part of the Academy. In the transcript of the subsequent investigation, the Romantics are criticized for their "impoverishment of form" and "stubborn attempts at originality which reduce art to childishness."[15] When, in 1812, Metternich became trustee of the Academy, some hoped that, because of his connection with the Hofbauer circle, there would be an immediate resurgence of religious art. Such optimists had not counted on the Prince's intense dislike of the entire Romantic movement. The Academy was not to be reformed overnight.

There were, at this time, a number of Austrian Romantics who formed their own circles and had only fleeting contact with the Brotherhood and their followers. These Austrians had a close affinity to nature, to all that is lyrical and beautiful, but they lacked the fierce underlying moral imperative of the Germans. Although Moritz von Schwind (1804-1871) studied with the German Schnorr von Carolsfeld and left Vienna for Munich, his poetic illustrations of fairy tales and legends and his series depicting "good moments"[16] display a distinctive lightness of touch. When Leopold Kupelwieser (1796-1862) visited Italy in the early 1820's he was not inspired, like the Germans, by the environment, but rather feared he would lose the "genuine, beautiful fresh foundation"[17] that he had acquired in Austria.

While a small number of key artists struggled to come to terms with the ideals promulgated by the Nazarenes, most Austrians were throwing themselves headlong into the phenomenon now known as "Biedermeier." Biedermeier, a term that originated after the era it described had vanished, was the name of a fictional poet who esteemed all things simple and plain.[18] This literary figure so epitomized the values of the period between the Congress of Vienna in 1815 and the 1848 revolution[19] that his name was given to the entire epoch. Biedermeier flourished in Germany as well as in Austria but did not squelch Romanticism in the former country to the extent that it did in the latter. Though the art of this era contains elements that might be considered romantic in the general sense of the word, it may be distinguished from German Romanticism by its restricted scale and lack of a grandiose vision.

"Progress is characterized by the fact that it appears much greater than it really is," wrote Johann Nestroy, the leading Austrian satirist of the day, thereby

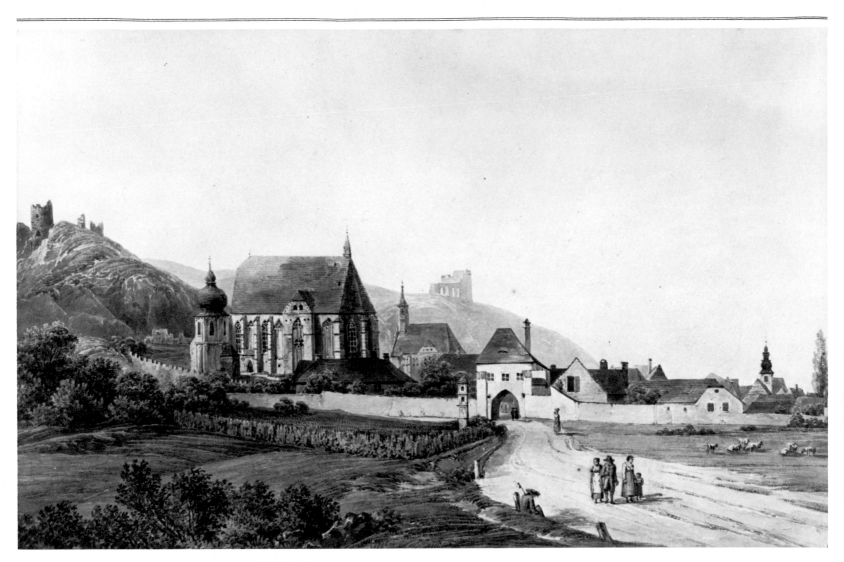

Figure 9 **Thomas Ender** Mödling with Both the Old Churches.

summarizing the guiding philosophy of his generation. That the Biedermeier was not an entirely pleasant time, either economically or politically, is proved by the fact that it culminated in a revolution, but for the middle class it was a comfortable time. The culture it spawned was predicated on a desire to postpone the inevitable, an escapism that focused on the glorification of the common man and his home.

As such, Biedermeier style was all-encompassing, penetrating every aspect of life, from furniture to fashion, from porcelain to painting.[20] Because of its comprehensive scope, Biedermeier

had a tendency to blur, ever so slightly, the distinctions that traditionally separate the fine and applied arts. The depiction of flowers, fruit and animals, once confined primarily to *Kleinkunst* (small art, i.e., crafts), had already in the 18th century become permissible for "fine" artists. Such subject matter was especially well suited to genre painting. One artist earned the epithet "Dog Raphael" because of the many dogs in his compositions.[21] Flower painting enjoyed a great vogue, and was even taught at the Academy, which tried to keep its distance from the thriving world of the applied arts. Many of the elabo-

rate images which adorned Biedermeier glassware and porcelain required at least as much artistic finesse as such subjects would if painted on canvas. It was, in fact, common for artists like Moritz Michael Daffinger (1790-1849) to find both "fine" and "applied" applications for their art (Figure 10).

For this paradise of the little man (*der kleine Mann*), nothing could be more appropriate than genre painting. Contemporary depictions show that the walls of the average dwelling were covered with pictures, made more affordable by the proliferation of inexpensive watercolors, silhouettes, engravings

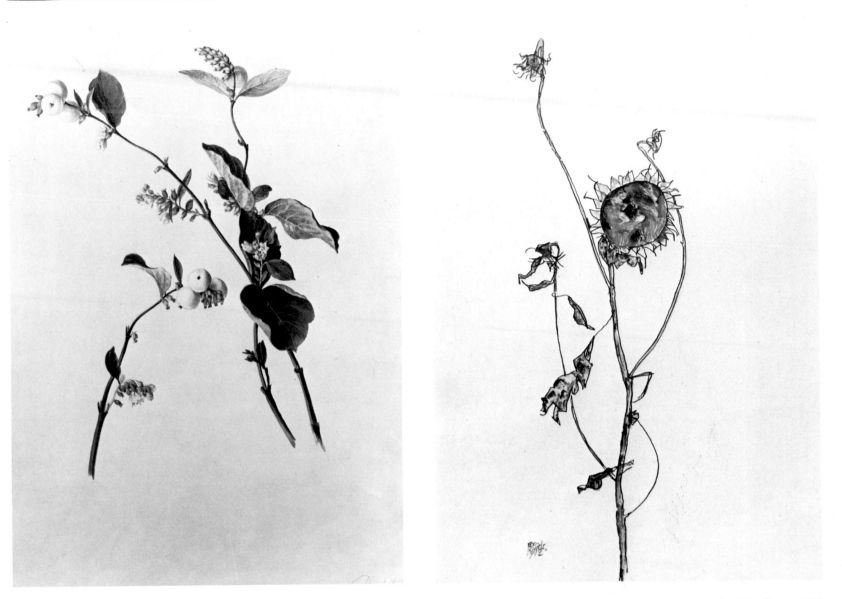

Figure 10 **Moritz Michael Daffinger** Snowberries. 1835.

Figure 11 **Egon Schiele** Wilted Sunflower. 1912.

and lithographs.[22] As art became accessible to the middle classes, their lives suddenly became more worthy of artistic representation. The way for this development was paved by the artist Jakob Gauermann (1773-1843), who added a new element to the usual "pure" landscape by incorporating peasant life in his *Picturesque Voyage Through Austria*, published in 1809. The activities of peasants, shown either in groups or personified in a single individual, remained an important theme for later genre painters. Depictions of "folk types" ("Croatian Onionseller," "The Mailman," "Hamburg Innkeeper")

were popular, as were idyllic scenes of family life and the world of children. Michael Neder (1807-1882) based his paintings on the daily occurrences in the Vienna suburb of Döbling, where he lived. He portrayed the routine sorrows and joys of these ordinary people in a straightforward style bordering on the primitive (Plate 1).

The sort of down-to-earth realism favored by the Biedermeier mentality was well suited to the development of landscape painting. Attractive views of scenic Austria gained favor and a whole group of *veduta*[23] or view painters arose, one of the most significant of

whom was Thomas Ender (1793-1875) (Figure 9). Rudolf von Alt (1812-1905), in the manner of the *veduta* painters, traveled about painting what he saw (Plate 4; Figure 6). However, his oeuvre resists association with a single school or movement, for his life spans the periods from Biedermeier through Jugendstil.[24] He overcame the narrowness of the Biedermeier approach with the breadth of his conception, which gathered the disparate elements of still life, landscape, portraiture and genre scenes to create an unsentimental portrait of an entire century. To achieve this, Alt carried the art of watercolor painting

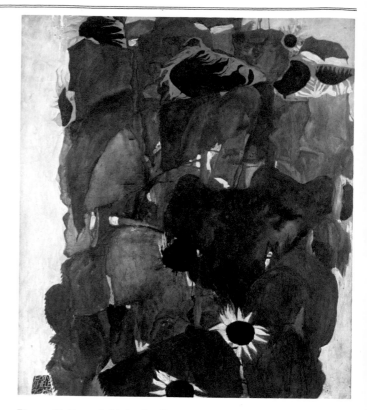

Figure 13 **Egon Schiele** Sunflowers. 1911.

Figure 12 **Ferdinand Georg Waldmüller** Fruit and Flowers. 1839.

to a level of perfection seldom equaled. His technique could describe detail with Biedermeier precision or express nuance with Impressionistic subtlety, and, in so doing, it surpasses the style of any one period.

Of all the artists of the Biedermeier, none can be said to better exemplify its characteristic feeling for nature than Ferdinand Georg Waldmüller (1793-1865).[25] That he has been called the "Austrian Ingres"[26] is a comparison that evokes as many antitheses as it does similarities. The metaphor finds its basis in the painters' shared predilection for smoothly "licked" picture surfaces and the depiction of minutely detailed fabric textures and patterns which is most evi-

dent in their portraits. They have in common a world view tinged with an element of wishful thinking, but, whereas the Frenchman elevates his subjects by placing them in classical or exotic settings, the Austrian transforms reality by idealizing the mundane.

Although Waldmüller's oeuvre runs the gamut of Biedermeier subject matter, it is in his landscapes that he excels. The earlier works, in which human activity is absent or subordinate to the sweep of the whole (Plate 2), capture the panorama of nature in gentle, easy strokes. Later, Waldmüller's technique tightened, his brush moving with painstaking precision to render each detail. Figures now assumed a more dom-

inant role in the composition (Plate 3). Although many of his idyllic scenes seem too good to be true, he was a confirmed realist. "No truth without nature" was his motto.[27] He adopted the practice of painting the landscape in bright sunlight, which he used not to dissolve his subject matter (like the French Impressionists) but to reveal it.

Ironically, this prime exponent of an historically conservative style himself ended as an embittered cultural outcast. After receiving a professorship at the Vienna Academy in 1830, Waldmüller became increasingly critical of the official attitude to art, which he felt stifled creativity. To counter this, he proposed the formation of a new art-

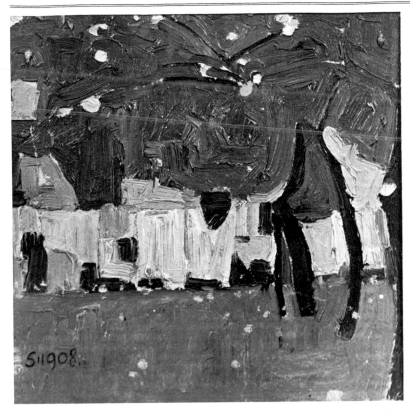

Figure 14 **Egon Schiele** Drying Laundry. 1908.

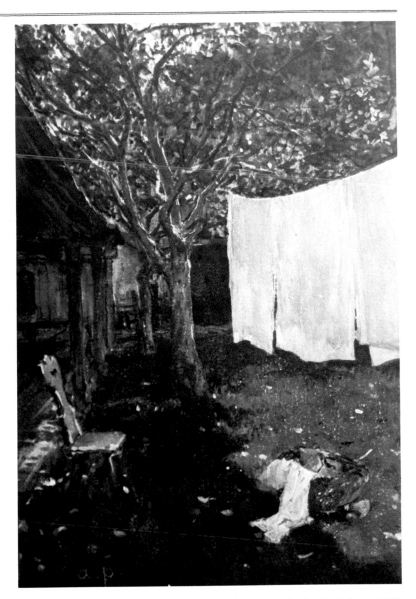

Figure 15 **August von Pettenkofen** Garden in Grünau. 1886.

ists' society that would promote national art both within Austria and throughout Europe and bring contemporary European art to Vienna. However, nothing came of this suggestion, and his animosity was deepened by an inability to sell his paintings in Austria. "It is as easy, as appealing, to beg for a living as to try to support oneself by painting," he wrote. "It is my heartfelt conviction that the complete dissolution of the entire Academy is the first and most necessary step in the creation of a new position for [our] national art."[28] Such sentiments, needless to say, were not destined to win Waldmüller friends in high places, and in 1857, he was summarily retired from the

Academy at half the prescribed pension.[29]

Meanwhile, Romanticism was beginning to transform the standards of landscape painting. The Biedermeier formula of pleasing colors, smooth paint surfaces, small formats and sunny days was being supplanted by a preoccupation with atmospheric effects and raging storms. At its worst, this trend resulted in something called a *Stimmungsbild* (mood picture), which comprised images of cemeteries and melancholy landscapes with lachrymose titles.[30] Painters abandoned the gentle green plains and headed for wild mountain territory. Their pictures evidence a progressive loosening of

contour, blurring of detail and enlivening of brushwork.

As the century wore on, a more contemporary revolutionary movement, French Impressionism, replaced German Romanticism as the newest foreign influence, and artists gravitated to Paris. However, the Austrians could not relax their grasp of the tangible object enough to embrace the refined optical reality of the French. One who came close was Carl Schuch (1846-1903), though he disassembled matter more to arrive at its spiritual essence than to analyze its formal makeup. As he was one of those whose activities centered in Munich, and since he rarely exhibited, his work did not become

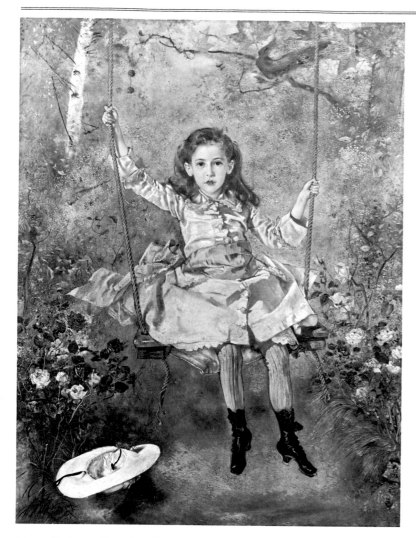

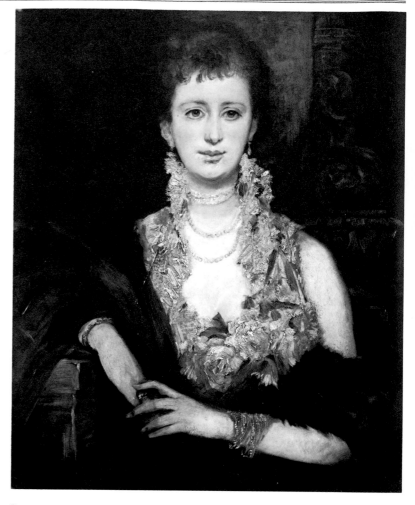

Figure 16 **Anton Romako** Girl on a Swing (Olga von Wassermann). Ca. 1882.

Figure 17 **Hans Makart** Clothilde Beer. Ca. 1880.

generally known until after his death. More influential, though less radical, was August von Pettenkofen (1822-1889). Pettenkofen was fascinated by the exotic peasant life of the Hungarian town of Szolnik, which he painted repeatedly over the course of thirty years. He developed a technique in which quick strokes of color describe the play of light on shapes, loosening their internal surface makeup without obliterating their boundaries (Plate 5). In his later watercolors, the use of this more fluid medium invites further dematerialization of the object, but the artist remains concerned with the interplay of discrete forms (Figure 15). Emil Jakob Schindler (1842-1892), influenced by Pettenkofen and also the Dutch Masters and the Barbizon School, went be-

yond Pettenkofen less in substance than in form. His bold proto-Expressionistic handling of the brush gives his subjects a more "advanced" appearance, but, like the older artist, he does not violate the integrity of the individual object.

Romanticism eventually found its strongest foothold in that very center of conservative authority which had initially repulsed it. This change in aesthetic orientation was conditioned by a major change in Vienna's cultural climate. At the end of 1857, the Emperor Franz Josef signed a decree ordering the destruction of the medieval walls that surrounded the inner city, clearing the way for the much-heralded Ringstrasse. Here, flanking the broad boulevard, new public buildings were

constructed in old, historic styles. This flurry of activity rejuvenated Vienna as an artistic center, attracting artists from all over the continent to contribute to various projects.

Many of the artists who were drawn to Vienna had ties with Germany or the Romantic movement. Romantics had slowly infiltrated important positions. In 1834, Schnorr von Carolsfeld was named curator of the Belvedere (now Österreichische Galerie). Two years later, Kupelwieser, who had been rejected in 1829, was gránted a professorship at the Vienna Academy. In 1860, Albert Zimmermann (1808-1888) came to Vienna from the Munich Academy, and not long after, Moritz von Schwind returned to create a group of frescoes for the new Burgtheater. Heinrich Rahl

(1812-1865), who had until 1850 spent much of his time in Italy and Munich, was now commissioned to paint murals for buildings such as the Vienna Opera House. Anselm Feuerbach (1829-1880) was another who came from Germany during the Ringstrasse boom.

The union of painting and architecture in a total aesthetic environment had been one of the dreams of the Romantics. It had led to the revival of classical fresco technique, which Kupelwieser introduced to Vienna in 1830. Opportunities for artists to collaborate on appropriate group projects began, by and by, to materialize, frequently in the form of commissions to decorate churches.[31] The development of the Ringstrasse, however, presented an unprecedented opportunity for such efforts.

The new atmosphere in Vienna engendered a completely altered attitude toward the arts. Gone was Biedermeier privacy in this age of public spaces. Art increasingly concerned itself with power and status. Portraits assumed a ceremonial function, and history painting lost its escapist aura and began to more directly reinforce the present regime. Lofty concepts and majestic imagery, out of fashion in the Biedermeier era of common sense, were ideally suited to Ringstrasse art. Such robust subject matter reflected Romantic spiritualism far more directly than had timid Biedermeier idealization.

Without a doubt, the most famous painter of the time was Hans Makart (1840-1884). Makart, having found the Vienna Academy inadequate, went to Munich in 1861 to complete his education. From there, he traveled to London and Paris and eventually Italy, Egypt and Spain. The purpose of these trips was primarily to absorb paintings by the great masters, which Makart committed to memory and then reproduced piecemeal in his own compositions. His monumental canvases created a sensation abroad, and in 1869, the Imperial

government invited him to return to Vienna, offering, at its own expense, to provide him with a studio. The "Makart Style" took Vienna by storm. Women wore Makart hats and decorated their parlors with Makart bouquets of dried flowers. Huge new paintings, which the artist turned out with amazing speed, were eagerly anticipated. The exhibition of one drew a record crowd of 40,000 people in five days.[32]

In retrospect, Makart has not fared as well with art historians as he did with his contemporary public. His modeling of the human figure has been called flabby and slipshod. His penetration of the personality was nil. His magnificent compositions, relying on intensity of color, blend with surrounding gold wall ornaments to become mere decoration. Appropriately, his greatest achievement was not a painting but a spectacle: a mammoth festival parade (*Festzug*) arranged to celebrate the Emperor's twenty-fifth wedding anniversary in 1879. Whatever the relative merits of Makart's various accomplishments, his very bright spark was rather rapidly extinguished when he died of syphilis at the age of forty-four.

During this era, which must be viewed as rather derivative, one painter distinguished himself with work of exceptional originality. Anton Romako (1834-1889), in spite of his initial success, became alienated from contemporary trends and could receive proper recognition only in the 20th century. A letter to a fellow artist, written when Romako was a sixteen-year-old student at the Munich Academy, already typifies his belligerent attitude. "You say you don't want to be a hack—a worthy ambition," he wrote. "But you can only hope to achieve this if you stay far away from Waldmüller, who is of that petty school from which everything beautiful and exalted has been banished, whose only greatness consists of proficiency, which is limited to shading, brushwork and color mixture. . . . You must always

have the spiritual poetry of art before your eyes, otherwise it's just a waste of time."[33]

Romako's disdain for the Biedermeier approach and his Romantic talk of spirituality could, by 1850, hardly have been considered revolutionary. Nor should his unusually loose brushwork have offended his contemporaries: Makart, either out of sloppiness or design, wielded his brush in even broader strokes. However, a comparison of Romako's *Portrait of the Empress Elisabeth* (Plate 7) with Makart's depiction of *Clothilde Beer* (Figure 17) reveals certain crucial differences of presentation.

In the Makart, all elements of the composition combine to reinforce the status of the sitter. The solid masonry against which she poses locates her in a recognizable space. The firm disposition of her forearm and hands is accentuated by the sweep of her stole, which is in turn reinforced by the bodice of her dress. The whole, through a series of rounded motions, serves to draw attention to the woman's face and neck. A fairly simple interplay of light and dark augments this basic structure.

By comparison, Romako's Empress Elisabeth, probably painted from a photograph, inhabits a much less definite space. Flecks of color dance around her, inexplicably cutting her off below the shoulders so that she appears disembodied. The application of pigment and color has somehow become divorced from the accepted notion of portraiture. Instead of serving a preconceived end, these elements function as independent expressive entities. The result is that we are not seeing a conventional portrait of the Empress, but a portrayal of Romako's conception of the Empress. For the first time, the ideal of art is not situated in an external theoretical construct. It lies within the artist himself.

SECESSION

The year of Waldmüller's forced retirement, 1857, saw Vienna on the eve of a new era in which his dream of a national artists' association was soon to be fulfilled. In November 1861, Franz Josef sanctioned the Genossenschaft Bildender Künstler Wiens (Vienna Society of Visual Artists). By 1870, the Genossenschaft, or Künstlerhaus as it came to be known, had opened its own exhibition hall. Were Waldmüller still living, he might have been pleased to see the work of Austrian painters displayed side by side with that of their French and German contemporaries, but the Viennese were too enthralled by "Makartism" to pay much attention.[34]

Makart, at the peak of his fame, received perhaps his most important commission shortly before his untimely death. That project, the decoration of the great staircase hall in the new Kunsthistorisches Museum, seemed almost to carry a curse. The next man to tackle it, Hans Canon (1829-1885), died before he could do more than complete preliminary sketches. In 1890, the assignment finally went to a promising trio of young painters who had won accolades for their work in the Burgtheater several years earlier: Franz Matsch (1861-1942), Ernst Klimt (1864-1892) and Gustav Klimt (1862-1918).

Within the next decade, Gustav Klimt, Makart's heir apparent, had made two moves which would forever separate him from the safe world of Ringstrasse Historicism. The Künstlerhaus, seemingly a progressive innovation, never strayed far from the close confines of respectability. In the nineties, a coalition of younger artists succeeded in winning some concessions within this conservative institution, but, as they became increasingly vociferous, the established leadership became more antagonistic. In April 1897, a new group, headed by Klimt, was formally organized with the intention "of bringing Vienna into more active contact with the advancing development of art

abroad . . . of awakening in wider circles a modern view of art, and lastly, of inducing a heightened concern for art in official circles."[35] The extent to which this plea paraphrases that of Waldmüller forty years earlier indicates the extent to which the Künstlerhaus had failed to serve its purpose. Though the Klimt group did not intend to make a total break, they were left with little choice when the executive committee of the Künstlerhaus voted to censure them. Thus was the Secession born.

Klimt and his followers remained in the good graces of the authorities. Help from the city government enabled the Secession to secure land for an exhibition hall with record speed, and the building itself was constructed within a few months.[36] In 1898, Klimt officially received yet another major commission: the ceiling paintings for the auditorium at the University of Vienna.[37] More than the founding of the Secession, Klimt's execution of this commission marked the end of his career as a purveyor of tame public art. Although there were already hints of trouble when Klimt presented his final sketches to the Ministry of Education, he did not come into open conflict with established taste until 1900, when the first of the University panels, *Philosophy*, was exhibited at the Secession. What was perhaps most shocking to his contemporaries was the painting's unabashed nudity. The imagery went beyond literal physical nakedness to suggest a spiritual nakedness. Lofty concepts had always been presented in lofty settings, be they religious, historical, mythological or literary. Such settings hold the viewer at a distance. Klimt's *Philosophy* brought its theme too close for comfort.

Klimt's use of symbolism is a not illogical extension of Historicism, for both approaches depend on metaphor. What provided a more radical element in Klimt's work was his association with that faction of the Secession which placed its emphasis on practical design

applications. The notion of collaboration on a *Gesamtkunstwerk* (total work of art) was not new. It had motivated the Romantics and found concrete expression in the buildings of the Ringstrasse. However, it was left to the Wiener Werkstätte (Vienna Workshops), founded in 1903 by Josef Hoffmann (1870-1956) and Koloman Moser (1868-1918), to extend the concept to embrace every article of human use. That Austria had in the previous century embarked on an artistic program whose effect, if not conscious intention, was the unification of the fine and applied arts was a precedent not lost on Hoffmann and his followers, who openly admired the Biedermeier. The presence of these crafts-oriented individuals in the Secession, however, did not sit well with the many members who favored old-fashioned easel painting, and after a few squabbles of varying intensity, the *Klimtgruppe* in 1905 went off on its own.

Klimt's work had always betrayed a feeling for design and pattern. Architectural forms, often neoclassical in style, surrounded much Ringstrasse wall painting, and were on occasion touched up with gold. The incorporation of broad architectural masses—the internalization of what had formerly been external—gave an abstract quality to some of Klimt's early canvases. Unlike older painters, he did not use architectural elements for classical ambience, but to provide a rigid and essentially two-dimensional compositional structure. Simultaneously, he began using gold to heighten the decorative effect of his work. From the edges inward, the metallic color seeped into his canvases, first as an extension of the traditional frame or border, and ultimately as an integral component of the image.[38]

As abstract form became more dominant in Klimt's work, the position of the human figure became increasingly tenuous. Gone, finally, was the architectural illusion, and the three-dimen-

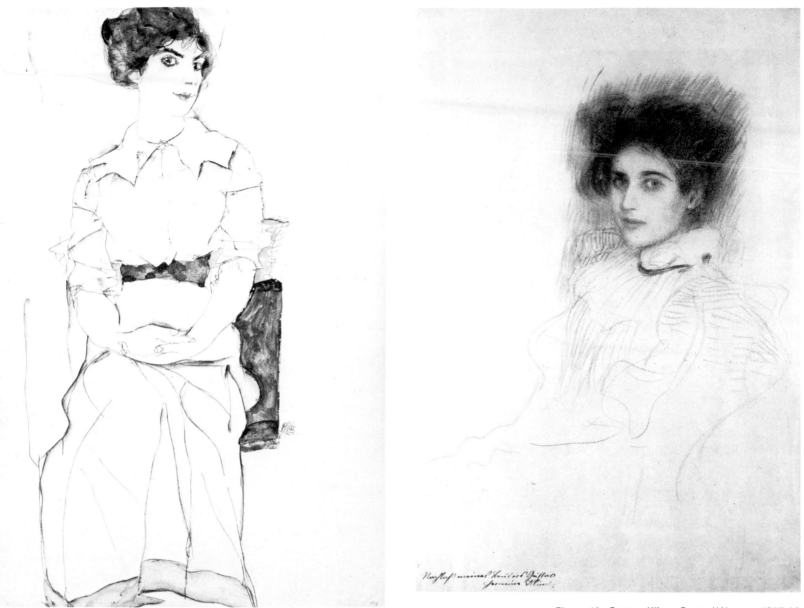

Figure 18 **Egon Schiele** Portrait of Elisabeth Lederer. 1913.

Figure 19 **Gustav Klimt** Seated Woman. 1897-98.

sional figure looked ill-at-ease in the resultant flat space. Around 1907 or 1908, Klimt turned away from the flashy brilliance of his gold paintings[39] in a muted canvas, *Pale Face* (Plate 8).[40] The simplified shapes of this composition served as an antidote to the proliferation of Art Nouveau decorative detail in his previous work. In subsequent paintings, Klimt employed softer forms and richer paint textures to achieve a gentler pictorial unity.

Meanwhile, the goal of bringing new foreign art to Vienna was gradually being achieved. The Secession's ex-

hibitions favored Symbolists such as Klinger, Khnopff and Toorop, or artists active in the crafts movements of foreign lands.[41] Work by Rodin, Renoir, Pissarro, Signac and other French artists was shown. In 1903, the Secession mounted a major survey of Impressionism, which traced its roots to the contributions of Velázquez and Goya, as well as including more advanced painters such as Gauguin and van Gogh. Paintings by Munch were exhibited twice in the Secession's early years. An ambitious show of Japanese art was less than successful, though it im-

pressed a number of Viennese artists. The Secession lost most of its sparkle after the departure of the *Klimtgruppe*, and it was not until the Kunstschau in May 1908, that Vienna could boast of an exhibition comparable in caliber to those held before 1905. Klimt arranged a total of two Kunstschauen. The first was devoted entirely to Austrian art, with the emphasis on designed objects, while the second, in 1909, was international in scope and included Munch, van Gogh, Gauguin and Matisse.

Figure 20 **Richard Gerstl** Small Street Painting.

REBELLION

The Vienna Academy weathered the various *fin de siècle* innovations with little change in its traditional stance. No person has come to better exemplify this institution's retrograde position than Christian Griepenkerl (1839-1916). Originally drawn into the Vienna art scene when Carl Rahl asked his assistance in completing a mural of the Prometheus legend,[42] Griepenkerl was in 1874 awarded a professorship at the Academy. His notoriety as a teacher has earned him more attention than any of his exploits as an artist, and he is especially remembered for his run-ins with Egon Schiele (1890-1918). Certainly his combination of brutality and obscenity renders him a unique educator. Several years before his encounter with Schiele, he is said to have told Richard Gerstl (1883-1908), "The way you paint, I can piss in the snow."[43]

Richard Gerstl

Richard Gerstl remains one of the enigmas of 20th-century art. Precociously ahead of his time, isolated by his own dignified sense of superiority, he nearly succeeded in obliterating all trace of his activities. Gerstl's troubles manifested themselves in childhood, marking him as a "difficult" student whose insubordination occasioned his transfer to a private school. Still, his family was relatively supportive, well-to-do and, one can surmise, willing to assist him financially.[44] In 1898, he entered the Vienna Academy, but, finding the atmosphere intolerable, he left in the summer of 1901. For the next few years, his studies were primarily self-directed.[45] While continuing to live at home, he rented a room elsewhere to be able to work undisturbed. In 1904, he returned to Griepenkerl's class at the Academy, but again it did not last long. Though his performance was graded "satisfactory," he was allegedly expelled after two semesters. Around this time, Gerstl was sharing a studio with

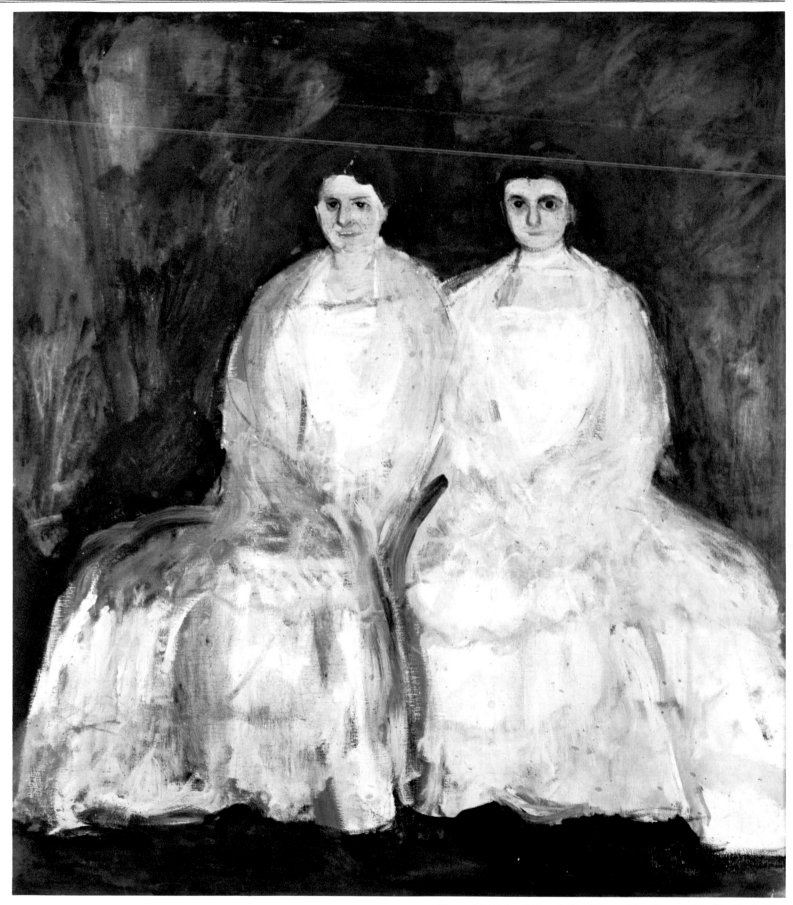

Figure 21 **Richard Gerstl** The Sisters (Karoline and Pauline Fey). 1905.

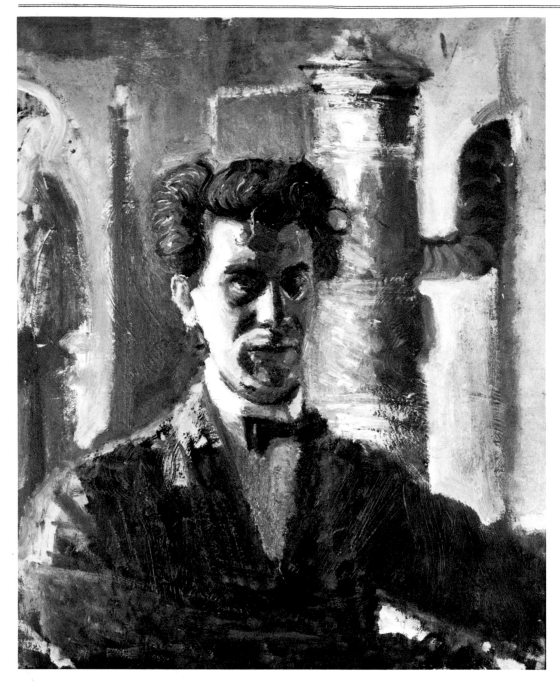

Figure 22 **Richard Gerstl** Self-Portrait in Front of the Stove.

Victor Hammer (1882-1968), a fellow student at the Academy who had switched to the more progressive class of Heinrich Lefler (1863-1919). Lefler saw Gerstl's monumental portrait of the Fey sisters (Figure 21), now at the Österreichische Galerie, and became interested in the young artist. Gerstl was subsequently invited to join Lefler's class, where he studied for about two years.

Gerstl, a quiet and withdrawn boy, had few close friends. He avoided social contact with other painters, but felt drawn to the company of musicians. Thus it was that he became involved with Arnold Schönberg and his circle. Ostensibly in the position of painting instructor, he spent the summers of 1907 and 1908 in Gmunden with the composer's family.[46] At some point in their association, Gerstl and Schönberg's wife Mathilde became attracted to each other. During their second summer in Gmunden, the two ran off together. Eventually, Anton Webern, by appealing to Mathilde's sense of motherly duty, persuaded her to return to her husband.[47] The breakup of this relationship had a devastating effect on Gerstl, all the more so because the loss of his mistress had naturally been preceded by the severing of all personal ties with the Schönberg group. On November 4, 1908, Gerstl destroyed most of the contents of his studio, erasing much of his life's work as well as notes and letters which might have illuminated it. The next morning, he was discovered with a knife in his chest and a rope around his neck, a suicide at the age of twenty-five.

Public acclaim, artistic success as it is routinely measured, was the least of Gerstl's concerns, and it is ironic that, in an effort to conceal the Schönberg affair, Gerstl's commercial failure was long given as the reason for his suicide. In fact, Gerstl could have exhibited at the Galerie Miethke, but turned the offer down, refusing to have his work

seen in a room where paintings by Gustav Klimt would also be hung.[48] He was contemptuous of most Viennese artistic endeavors, and not shy about making his opinions known. He was particularly appalled, as the Sixtieth Jubilee of Franz Josef's reign approached, to see preparations under way for another *Festzug* à la Makart. When his teacher, Lefler, one of the hordes of artists recruited for the undertaking, got wind of his student's attitude, Gerstl was asked to vacate his studio.[49] Once, Gerstl even went to the extreme of lacerating his own work when it was praised by an acquaintance whose opinions he found repugnant.[50]

Disdainful as Gerstl was of his aesthetic environment, no artist can remain completely immune to outside influences. Some have observed a relationship between Munch's melancholy portraits and Gerstl's brooding figures, although his studiomate, Victor Hammer, did not recall his mentioning the Norwegian's name.[51] Gerstl was, on the other hand, enthralled by van Gogh, whose work had been included in the 1903 Impressionism show at the Secession and in a one-man exhibition at Miethke three years later. Van Gogh's influence can be clearly seen in the febrile trees and fields of Gerstl's *Grinzing* (Plate 14). Schönberg, who went on to achieve a modest reputation as a painter, considered himself to be the decisive influence, though the composer's most fertile period as a painter began only in 1910.[52] With a trace of bitterness, which under the circumstances must be discounted, Schönberg has said of Gerstl: "When this person invaded my house, he was a student of Lefler, for whom he supposedly painted too radically. But it was not quite so radical, for at that time his ideal . . . was Liebermann. . . . When he saw some quite miscarried attempts of mine, he took their miserable appearance to be intentional and exclaimed, 'Now I have learned from you how one has to paint!' . . . Immediately afterwards he

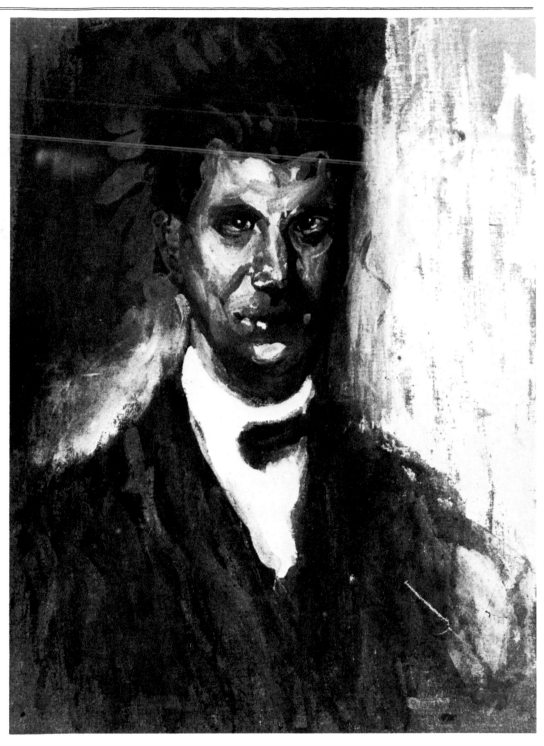

Figure 23 **Richard Gerstl** Self-Portrait, Study.

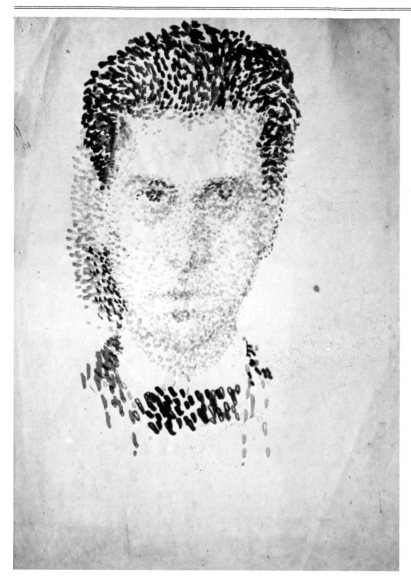

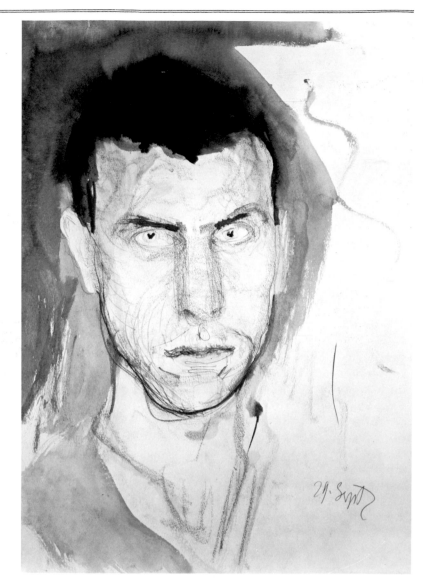

Figure 24 **Richard Gerstl** Self-Portrait. Ca. 1906.

Figure 25 **Richard Gerstl** Self-Portrait. 1908.

started to paint 'Modern.' "[53]

It does not seem altogether unlikely that Gerstl and Schönberg, who had lengthy discussions of aesthetic theory, influenced each other's approach to art. The notion of painting and music as kindred forms of expression was to gain currency with the German Expressionists. It was, in fact, a logical extension of the Romantic search for spiritualism in art. As visual subject matter becomes more esoteric and conceptual, it assumes an abstract communicative purpose similar to that of music. One of the most eloquent proponents of such ideas, Wassily Kandinsky, became friendly with Schönberg several years after Gerstl's death.[54]

Kandinsky would later write that Schönberg, by "renouncing the objective result . . . seeks to affix only his subjective feelings. . . . Just as in his music . . . Schönberg also in his painting . . . proceeds along a direct path to the essential."[55] As Schönberg struggled to free musical composition from conventional tonal structure, so did Gerstl, flying in the face of all that was considered proper, strip painting down to an emotive core. For a brief time, the musician and the painter worked side by side toward the same goal, each in his chosen medium.

Stylistically, Gerstl was deeply affected by the work of the Impressionists and Post-Impressionists that was gradu-

ally infiltrating Vienna, but, like the 19th-century Austrian landscape painters before him, his response was conditioned by an entirely different attitude. When Gerstl toyed with the disintegration of physical substance, he revealed not a scientific formula of appearances but the underlying spirit of the object. Gerstl's use of pointillist dots in two self-portrait wash drawings (Figure 1 and 24) yields a distinctly Expressionist result. The strokes are animated not by the play of light but by the force of emotion. By reducing form to a network of spots, the French had hoped to demonstrate the uniform optical makeup of each object. Gerstl, with uneven jabs of pigment, transforms this inherently

regular technique to probe the irregularities of the human soul. In later self-portraits (Figure 25), Gerstl abandoned the pointillist approach, supplementing the grayish wash with pencil, crayon and pen lines to achieve greater impact.

Gerstl might have denied harboring a secret admiration for Gustav Klimt, but certain parallels do exist between the two. Klimt, especially in his landscapes, reordered reality according to personal design concepts. Glimmering pattern superceded objective verisimilitude, causing the picture surface to function as an independent visual entity (Plate 12). Gerstl achieved a similar effect by interpreting the external world subjectively. The breakdown of the image into component brushstrokes, each of emotional significance, is visually analogous to Klimt's subordination of the whole to its decorative components (Plate 13). In Gerstl's work, as in Klimt's, the canvas assumes an independence from a collective reality and represents a self-contained world of the artist's creation.

Oskar Kokoschka

It had long been the rule in Vienna that more freedom was permitted in the applied than in the fine arts. Thus it stands to reason that, at a time when the Wiener Werkstätte represented a most powerful arm of the avant-garde, the Kunstgewerbeschule (School of Applied Art) was more liberal than the Academy. There was, as might be expected, a strong emphasis on Art Nouveau design at the Kunstgewerbeschule. As Oskar Kokoschka (1886-1980), a former student, later observed, the whole place ''was oriented toward ornamentation. Nothing but weeds and flowers and tendrils writhing about like worms.''[56] Although Kokoschka would have preferred more exposure to the human figure, he was grateful to the school that bought him paint and canvas when he could not afford them and,

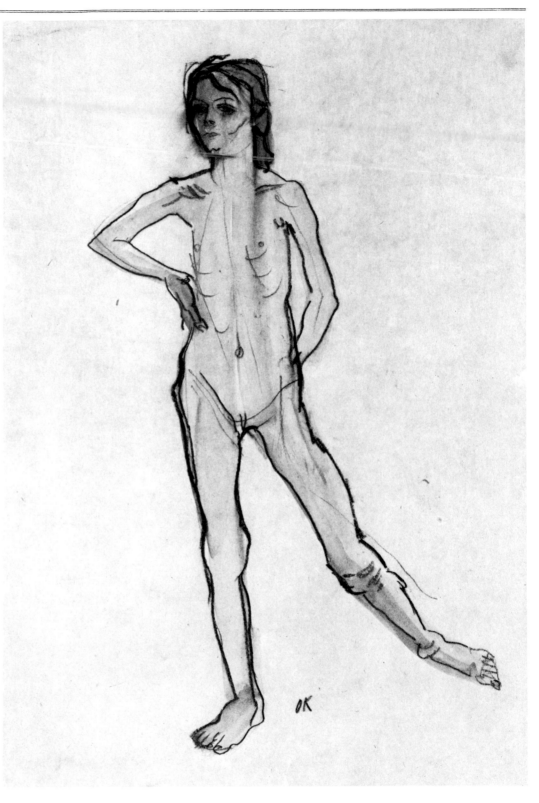

Figure 26 **Oskar Kokoschka** Savoyard Boy, Standing. 1912.

Figure 27 **Oskar Kokoschka** Tre Croci Landscape. 1913.

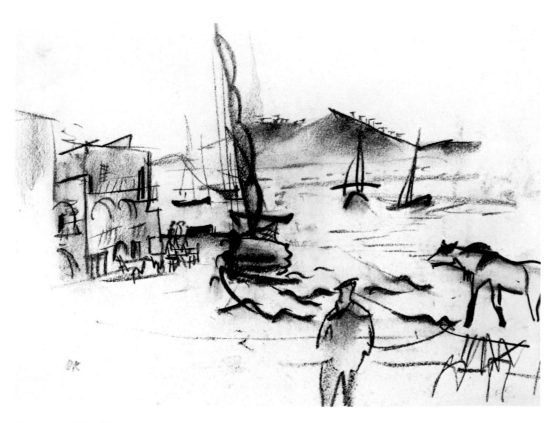

Figure 28 **Oskar Kokoschka** The Coast of Naples. 1913.

after two years, hired him as a part-time teaching assistant. Considering that when Kokoschka's work was exhibited publicly several years later he was almost run out of town, the early support of the Kunstgewerbeschule is not to be taken lightly. Teaching methods, too, were unorthodox. In 1901, Alfred Roller (1864-1935) instituted the novel practice of making quick action studies of the human body "to transform motion by capturing the moving model with rhythmic strokes—to create an impression with simple means, not tiresome rendering of details, but the essentials of appearance."[57] When one remembers that, at the Academy, students were still copying plaster statues, it becomes clear how relatively invigorating the atmosphere at the Kunstgewerbeschule was.

It is not all that surprising, then, that Kokoschka, the *Bürgerschreck* (terror of the middle class) whom all Vienna loved to hate, was a product of the Kunstgewerbeschule. As a student at such a school, it was to be expected that Kokoschka would seek crafts applications for his art. In 1907, Josef Hoffmann invited him to work for the Wiener Werkstätte, for which Kokoschka designed bookplates, postcards, fans and, last but not least, a rather sophisticated "children's" book, *Die träumenden Knaben* (The Dreaming Boys). In 1908, his teacher, Carl Otto Czeschka (1878-1960), invited him to participate in the Kunstschau. Since many of Kokoschka's contributions to that exhibition have since disappeared, it is hard to assess just what occasioned the violent public reaction. It is known that a gaping sculptured head with exposed nerve endings painted on its cheek made a particularly bad impression, and the corner in which it was displayed was dubbed the "chamber of horrors."[58] The Kunstschau of the following year brought new outrages by young Kokoschka, including the per-

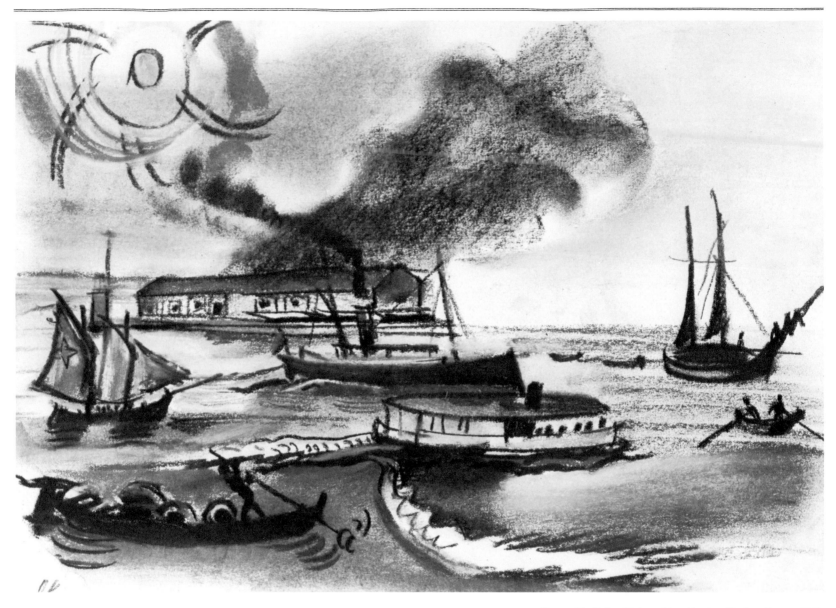

Figure 29 **Oskar Kokoschka** Naples, Harbor Scene. 1913.

formance of his play *Mörder, Hoffnung der Frauen* (Murderer, Hope of Women), which, by its title alone, suggests a theme designed to offend.

These scandals may have brought Kokoschka instant fame, but not of a sort that entails financial success. The negative publicity after the first Kunstschau cost him his job at the Kunstgewerbeschule. A subsequent attempt on his part to organize a class in bookbinding was also forbidden by the Ministry of the Interior. His appointment in 1913 to the position of art instructor at a private girls' school finally caused the Austrian authorities, no doubt haunted by thoughts of sexual atrocities, to forbid him from teaching altogether.

Despite this commotion, Kokoschka retained one loyal friend, the architect Adolf Loos (1870-1933). Loos was a confirmed iconoclast whose intimate circle included the social critic Karl Kraus and the poet Peter Altenberg (Figure 8).[59] The architect did his best to secure portrait commissions for Kokoschka. Toward the end of 1909, he brought the young artist to Switzerland, where he painted his first important landscape,[60] as well as several of the patients at the sanatorium where Loos' wife was staying.[61] In 1910, Kokoschka visited Berlin, and for the next four years he divided his time between there and Vienna, be-

coming a regular contributor to the German periodical *Der Sturm*.[62] The Germans, he found, were much more receptive to his work. In June of 1910 he had his first show with the Galerie Cassirer in Berlin, and in September, he was given a one-man show at the Folkwang Museum in Hagen. By way of contrast, a 1911 exhibition in Vienna again drew loud protests.

Around this time, Kokoschka began a tempestuous affair with Alma Mahler, the widow of composer Gustav Mahler. Kokoschka also became much more involved with printmaking, creating a number of book illustrations that related more to his troubled love life than

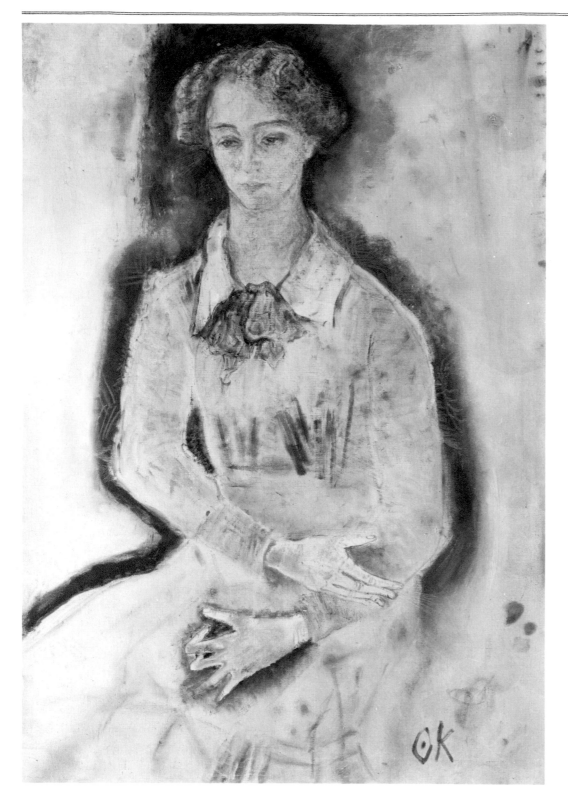

Figure 30 **Oskar Kokoschka** Lotte Franzos. 1908-9.

to the literary piece at hand. He was becoming increasingly depressed by the turn his encounters with Alma Mahler were taking, and continual Austrian rejection of his work did not help. The outbreak of war in 1914 seemed to offer an opportunity to escape, and though he knew from the start that he hated guns and could never kill anyone, he volunteered. In his monumental canvas *Knight Errant* (Plate 31), probably painted during the first year of the war, we see the artist's romantic vision of himself as a wandering soul, courting death to flee his sphinxlike lover.[63]

The situation Kokoschka encountered at the Russian front was far more brutal than the dreamy limbo he had imagined in his painting. Horrified by what he witnessed, severely wounded, the artist almost lost his will to survive. Settling in Dresden after the war, it was only through total immersion in his work that he slowly began to recover.

During these post war years, in the aftermath of the overthrow of the existing governments in both Austria and Germany, radicalism was suddenly in vogue. Needless to say, Kokoschka benefited from the new trend. His plays were performed throughout Germany and anthologized. He continued to illustrate books, and in 1918, the first biography on him appeared.[64] In 1919, he was given a professorship at the Dresden Academy.

Kokoschka left Dresden in 1924, and was for a period called back to Vienna due to the terminal illness of his father. Even at this late date, his work was an incitement to Viennese Philistines, and again Kokoschka left in disgust.[65] The following years were filled with far-reaching travels: Paris, London, Tunisia, Istanbul, Ireland, Scotland, Egypt, Algeria and Italy. From 1931 to 1934, he again centered his activities in Vienna, but with the rising tide of National Socialism, he was soon on the move again.[66] In 1953, he finally found a permanent home in Villeneuve, Swit-

zerland, where he lived until his death in 1980.

Kokoschka did not receive formal training in painting at the Kunstgewerbe-schule, and much of his early work bears evidence of his crafts background. Figures are stylized, as are their surroundings. However, the stylization thrives on an angularity of line, a distortion of form and a concern with the human element that lead away from the pleasantries of Art Nouveau. As a child, Kokoschka had been fascinated by the displays at the ethnographic museum. The primitive expression of something vital and elemental kindled the boy's imagination, and, unaware of similar impulses that were driving artists in other European countries to seek inspiration in tribal art, he naively pursued a parallel path to Expressionism. Later he would recall that, during these formative years, no "fine" artist, with the exception of Romako, aroused his interest.[67]

The nature and circumstances of Kokoschka's first experiments with oil paint are almost impossible to reconstruct, though it seems likely that they were encouraged by the portrait commissions that Loos brought him. Likewise, there is some question as to which of these early portraits was the first, though Kokoschka claimed it was the one of *Lotte Franzos* (Figure 30). "The girl was very close to me and I was extremely fond of her," he said. "That is why I suddenly knew how I had to paint her. I painted her like a candle flame: yellow and transparent light blue inside and all about, outside, an aura of vivid dark blue. . . . The Impressionists wouldn't have been able to do such a thing. They have an altogether different idea of light—how the eye is struck by sunbeams and reflections—while here it is sensibility on which light impinges; it's a spiritual light."[68]

The image of a candle is an apt one, for many of Kokoschka's portraits from this

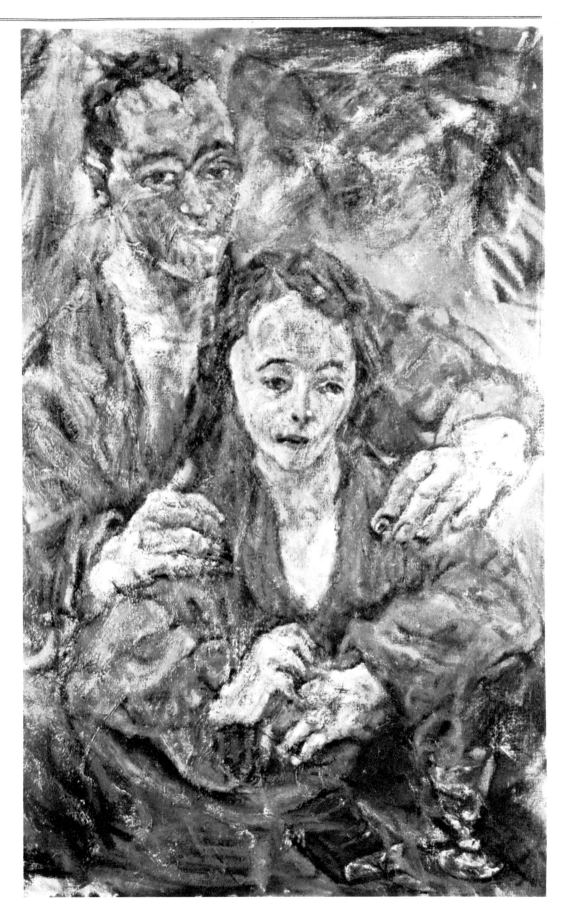

Figure 31 **Oskar Kokoschka** Sposalizio. 1911 or earlier.

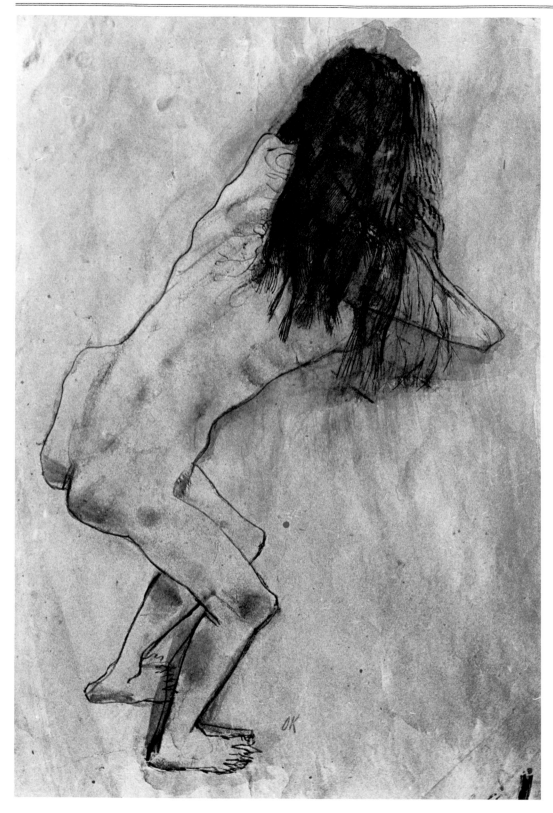

Figure 32 **Oskar Kokoschka** Nude with Back Turned. Ca. 1907.

time seem to radiate an inner glow. This is in part achieved by his application of pigment, which is scraped down to the threads of the canvas and then renewed, marked by incised lines as well as by the play of the brush. One feels not that the figure has been built up in careful layers of paint, but that he or she has been exposed.

This approach to portraiture did not endure more than a few years. Kokoschka's growing familiarity with the medium of oil paint made him want to explore its tactile qualities, the hues and textures that can be created by overlapping or juxtaposing strokes of color. This tendency peaked in the colorful impasto of his Dresden period. Undoubtedly, his increased participation in the German art world also conditioned a change in attitude. The Brücke artists,[69] who had first exhibited together in Dresden in 1906, moved to Berlin in 1911. The Blaue Reiter group[70] showed in Munich in 1911. Their famous "Almanac" was first published the following year, as was Kandinsky's *On the Spiritual in Art*.

Surely it can be no coincidence that in 1912 Kokoschka chose to formulate his philosophy of art in a piece titled "On the Nature of Visions" (*Von der Natur der Gesichte*). "The consciousness of visions is not a state in which one perceives or understands an object but a position in and of itself which must be experienced for itself," he wrote.[71] Kokoschka's painting had, already in Vienna, been true to this German Expressionist premise of separating the inner from the outer world. With his introduction to the German cultural orbit, his work was brought into contact with theirs, and what had formerly been instinctive was now seen to mirror a sophisticated aesthetic credo.

Ironically, the ensuing years of experimentation and self-education almost led Kokoschka "backward" toward physicality. The couple in

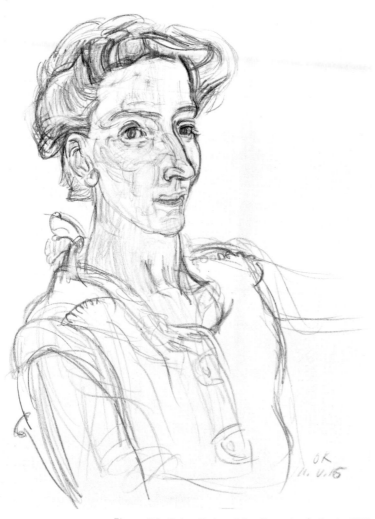

Figure 33 **Oskar Kokoschka** Portrait of a Lady. 1916.

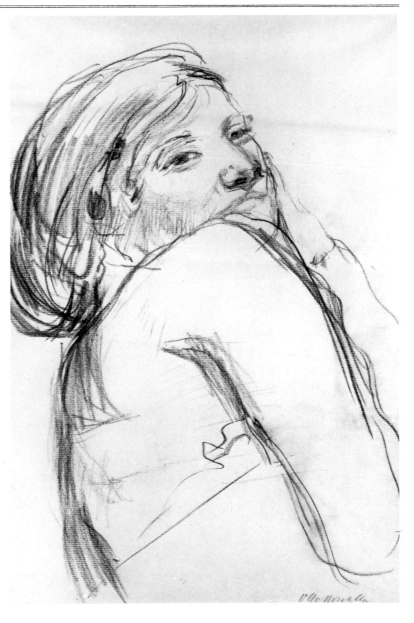

Figure 34 **Oskar Kokoschka** Mrs. M. (Mary Merson). 1931.

Sposalizio (Figure 31) evidence a new concern with volume, and his *Two Nudes* (Plate 25) are composed of solid slabs that suggest a Cubist influence. In his drawings one perceives a related smoothing of the once jagged line and a growing appreciation of overall surface contour. There has been a transformation of his view of the human body as a two-dimensional design entity to an awareness of form in all its dimensions.

During this period of contact with Germany, Kokoschka mastered not only technical fundamentals but human anatomical structure and the means of combining the two. Having learned, thereby, to construct shapes, he was free once more to break them apart. This he began to do again around the time he left Dresden. Increasingly he found expression in landscape, perhaps because during these years of travel, this subject matter best reflected his nomadic life. In *Lac d'Annecy II* (Plate 17), the artist demonstrates the full range of his creative power, surpassing reality not by violating its physical substance, but by using that substance in combination with the artistic tools of color and brushstroke as a vehicle for its own transcendence. In his mastery of the three dimensions, Kokoschka had never lost sight of that fourth dimension that was himself. ''The other three dimensions are based on the vision of both eyes . . . the fourth dimension is based on the essential nature of vision, which is creative.''[72]

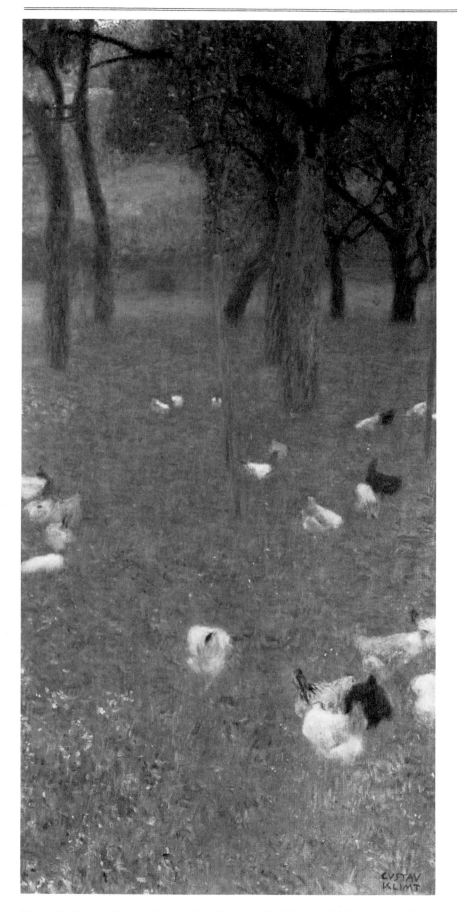

Figure 36 **Egon Schiele** Orchard in Spring. 1907. This painting seems clearly derived from Klimt's *After the Rain*, which Schiele could have seen at the Österreichische Galerie, where it had been since 1900.

Figure 35 **Gustav Klimt** After the Rain (Garden with Chickens in St. Agatha). 1899.

Egon Schiele

If Kokoschka began with a background in the applied arts and only gradually taught himself to paint and draw the human form, Egon Schiele, educated at the Academy, had more than he could take of the conservative rudiments of a "proper" art education. In 1906, he came to Vienna to study art, but soon found himself much more excited by the creations of Gustav Klimt than by Professor Christian Griepenkerl. The spirit of rebellion was in the air, and in 1909 Schiele founded his own *Neukunstgruppe* (new art group) and left the Academy. His freewheeling behavior and refusal to comply with his family's middle-class expectations especially infuriated his guardian, Leopold Czihaczek, who had assumed responsibility for the boy after his father's death. When in 1910 the guardian washed his hands of the whole business for good, Schiele's life became an ongoing struggle for financial assistance. He did, however, have a few good friends who helped him. In 1909, he met the critic Arthur Roessler, who became a lifelong supporter. Klimt, who admired the young painter, introduced him to wealthy collectors. As early as 1910, Schiele's work was exhibited at Miethke, and by 1913, he had been given one-man shows in some of the major cities in Germany.

Personally, Schiele remained at odds with a society shocked by the explicitness of his art and his bohemian ways. These troubles culminated in 1912 in his imprisonment on charges stemming from an involvement with an under-aged girl. The charges were eventually reduced, and he was released after twenty-four days. It was, perhaps, the trauma of this experience that persuaded Schiele to settle down to a more respectable life-style several years later. He broke off with his mistress, Wally Neuzil, who had won his heart by her loyalty during the prison ordeal, and in

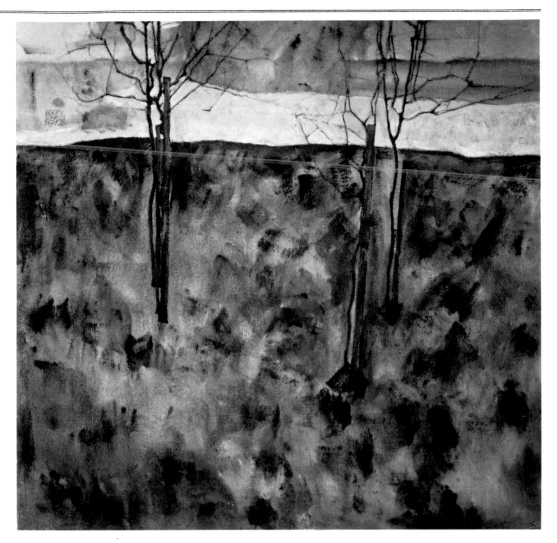

Figure 37 **Egon Schiele** Trees in Winter (Three Trees). 1912.

1915 married a nice middle-class girl, Edith Harms. However, the war separated the newlyweds almost immediately, as Schiele had to report for duty in the Imperial Army. By temperament, he was as ill-suited for soldiering as Kokoschka, and it was not long before he managed to have himself reclassified for limited service. He obtained the privilege of sleeping at home when stationed in Vienna, and in Mühling an entire barracks was put at his disposal for use as a studio. In 1918, Schiele had his most successful exhibition to date, at the Secession in Vienna. He did not have much time to enjoy this success, for both he and his wife succumbed to the Spanish flu epidemic in the fall of that year.

Schiele was less directly influenced by artistic occurrences in Germany than Kokoschka, for, except for brief trips to Munich, he almost never strayed beyond the borders of the Monarchy. He was not unaware, of course, of innovations outside Austria, and in certain paintings one can see distinct traces of Hodler, van Gogh,[73] and even a Schiele-esque variant of Cubism.[74] Perhaps the closest radical model for Schiele was provided by Kokoschka, whose appearances in the Kunstschauen predate the younger artist's 1910 "breakthrough" to Expressionism. Still, there are fewer obvious stylistic connections between Schiele's work before the war and that of Kokoschka than there are in his last paintings, whose heavier surface textures recall Kokoschka's technical experiments. The increased plasticity of Schiele's later works, though superficially comparable to Kokoschka's, could just as easily be interpreted as a return to the realism of his Academic training.

Schiele, like Kokoschka, found an early creative outlet within the confines of the decorative, and was perhaps more than any other Expressionist influenced by Gustav Klimt. Klimt had discovered that nature could be tamed by being subordinated to an overall pattern, smoothing away the distinctions between subject and background. For Klimt, pattern resolved itself in texture and detail; for Schiele, in line. For Klimt, the solution was the complication of form through ornament. For Schiele, it was simplification. Thus in his 1910 study for *City on the Blue River* (Figure 38), every element in the landscape becomes a block of color, each put together with the others like a child's puzzle. Within these segments, however, the artist's brush goes wild with the sensation of wet paint as it is sucked softly into the dry paper or swirled on top of the sheet, allowing the colors to puddle and blend. In his *Mountain Landscape* (Plate 15), painted the same year, Schiele exploits for maximum expressive effect the lines created by a brush cutting through thicker slabs of paint.

Schiele, perhaps conditioned by a national art that had for decades placed importance on the smallest details of the natural environment, never failed to find his inspiration there. The Biedermeier love of *Kleinigkeiten* (little things) became wedded to the Romantic notion of nature as the supreme manifestation of earthly spirituality. "Enjoy sacred nature and let the coolness of the evening affect you," Schiele wrote a female friend, presumably an artist. "Rejoice in the sensation of color in the morning, as in the evening, and by night dream of the enormous sea of stars. Follow the rich forms of the clouds with your line and experience a thunderstorm. And should you come upon a stream whose banks are bordered by blossoming meadows and dark forests, then let yourself be spoken to by the stream which rushes on and on forever."[75]

Schiele's landscapes speak as eloquently about his feeling for the emotions underlying the tangible world as anything he did, but it was his portraits that attracted the most attention both in his life and later, for it is there that one sees most clearly that "powerful artistic originality which at first repels, all the more to later enthrall."[76] The flowing nuances that animated Schiele's landscapes were even more stimulating when applied to the breasts and armpit hairs of the dancer Moa (Plate 21). The sensationalism of such subject matter is undercut by the uncertainty that Schiele conveys with a few slashes of black paint in the woman's eyes, and in her full but lopsided mouth. Schiele had a genius for capturing personality with the sparsest means, and they could as easily be applied to the socialite Elisabeth Lederer (Figure 18) or to a taciturn little girl (Figure 40) as to the trollops and urchins of Vienna. His approach could be almost painfully blunt, and nowhere is this more evident than in his nudes, which shatter the illusion of sex as a romantic or sentimental dream. *Die Traumbeschaute* (dreaming woman observed) was a title Schiele gave to one of his erotic watercolors.[77] This phrase captures the artist's general approach to sexual subject matter, for the dream observed is the dream exposed. In *The Red Host* (Plate 20), fantasy and reality collide with an impact that, even today, may be considered shocking. To call it exhibitionism is to miss the point. All art is exhibitionism, because what is painted becomes public. But what Schiele painted is, in some instances,

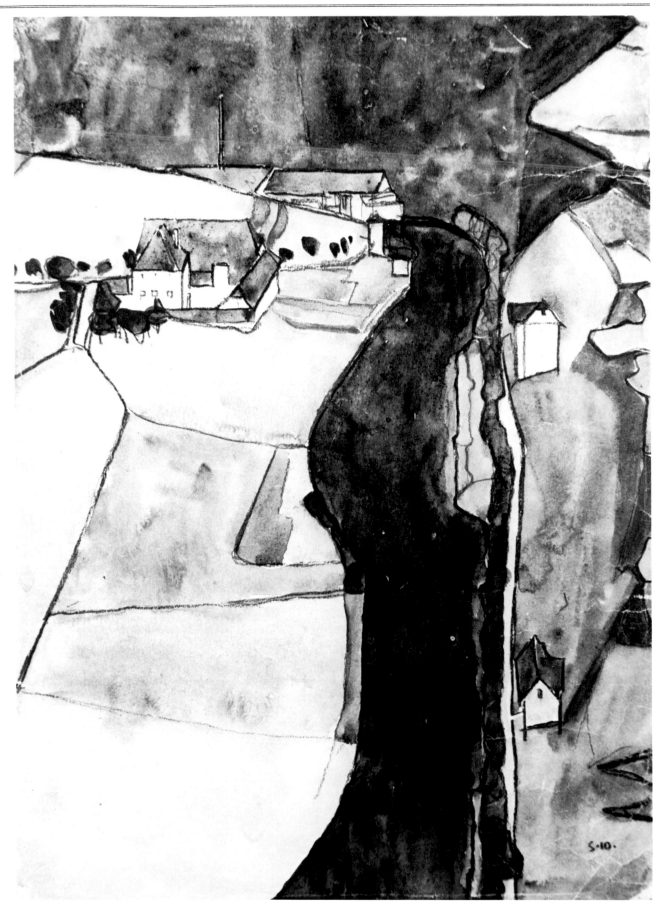

Figure 38 **Egon Schiele** City on the Blue River. 1910.

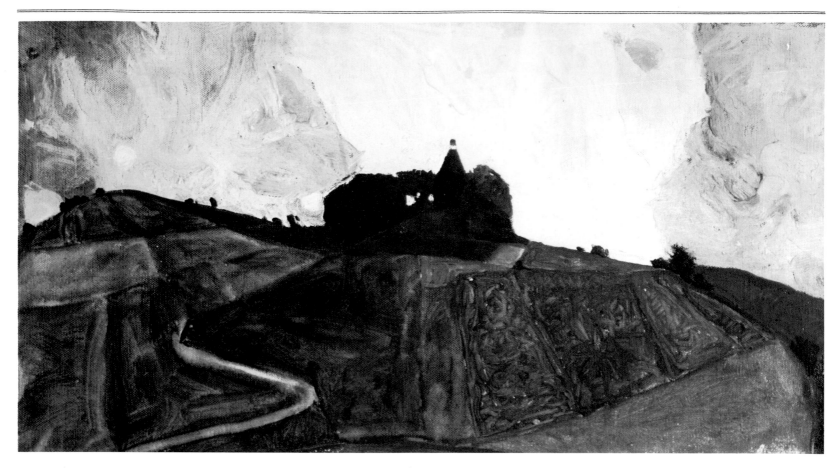

Figure 39 **Egon Schiele** Chapel on a Mountain (Thunderstorm Mountain). Ca. 1910.

something few others would dare make public.

Though there are those who consider Schiele's portraits his greatest achievement, the artist himself certainly felt differently. The dictum that great themes make great art was still persuasive. Klimt, having turned away from official commissions after the University debacle, continued to paint large allegorical compositions privately on such themes as life (pregnancy), aging and death.[78] The predilection for myth and legend, so dominant in the 19th century, was a powerful heritage, and even Kokoschka could not shake loose of it.[79] For Schiele, this urge was expressed in symbolic self-portraits[80] and metaphorical depictions of pseudo-religious rites or obscurely mystical experiences.[81] His explorations of profound themes, unlike those of his predecessors, were per-

sonal, not theoretical. Rather than selecting an abstract topic and endowing it with emotional impact, he chose an image from his emotional life and endowed it with symbolic import. Schiele's *Family* (Plate 27), loosely derived from the artist's own family,[82] becomes a general statement on family life because the viewer is able to identify with the characters. The protective but somewhat anxious father, the tired, resigned mother and the baby who embodies their hopes are all people whom we have met. In comparison, one finds it difficult to relate to the Biblical parents in Klimt's *Adam and Eve* (Plate 24). The serene, buxom blonde and her rhapsodic beau are creatures from a pretty story, not from life. Paradoxically, Klimt's idealization has made a universal story inaccessible, while Schiele's personalization has made a private story universal.

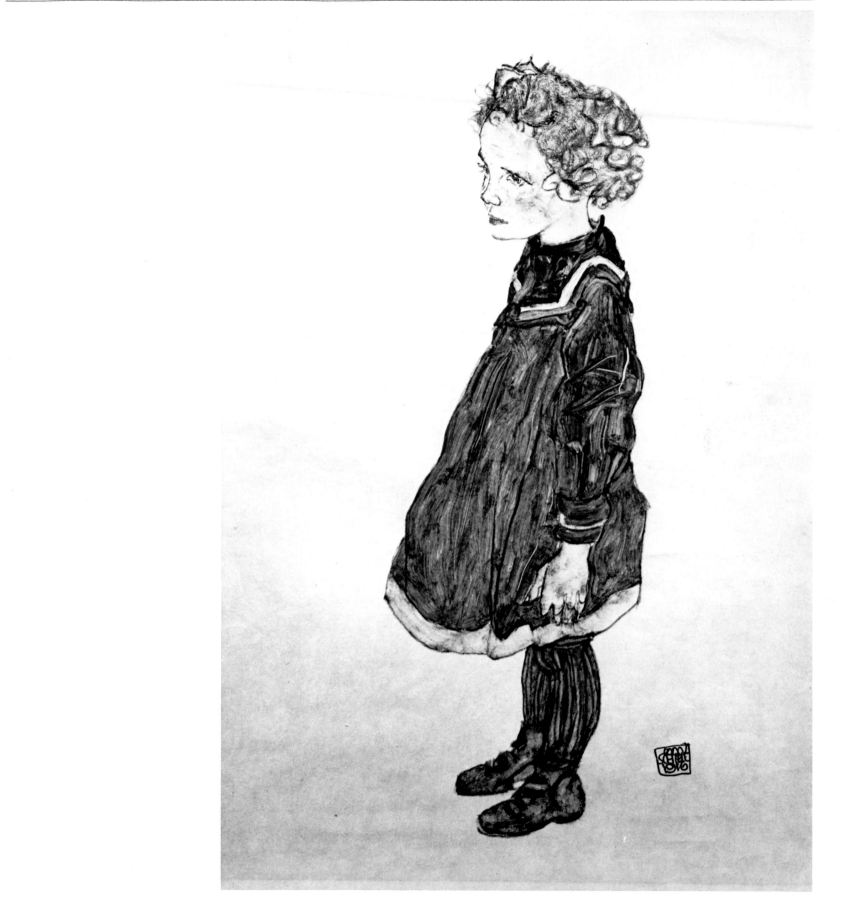

Figure 40 **Egon Schiele** Girl with Blond Hair in Red Dress. 1916.

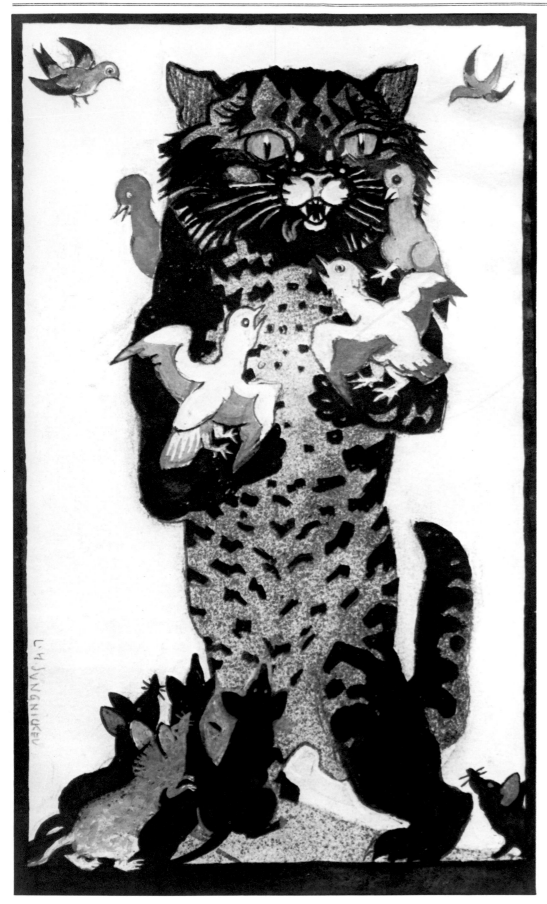

Figure 41 **Ludwig Heinrich Jungnickel** Hinze. Ca. 1917.

PARALLEL DEVELOPMENTS

Gerstl, Kokoschka and Schiele were the great Expressionist innovators in Vienna, but there were of course many other artists who came of age during this seminal era.[83] One, Ludwig Heinrich Jungnickel (1881-1965), began as an employee of the Wiener Werkstätte, while another, Oskar Laske (1874-1951), was at best ambivalent to the entire arts and crafts movement. A third, Alfred Kubin (1887-1959), had only loose ties with the Viennese art world. All three developed highly individual approaches to art.

Ludwig Heinrich Jungnickel

Ludwig Heinrich Jungnickel was a reclusive and secretive man, and today much of his life remains a mystery. In 1896, he studied at the Kunstgewerbeschule in Munich, and in 1899, like so many other unfortunates, he turned up in Griepenkerl's class at the Vienna Academy. He soon became fed up there and went off on his own, supporting himself by giving painting lessons and designing wallpaper. He continued to attend classes at the Academy sporadically, and for a time enrolled at the Vienna Kunstgewerbeschule. His work was included in the 1908 Kunstschau, and that same year he received one of his most important assignments, a wall frieze for the children's room in the Stoclet House.[84] The Stoclet House, to which Klimt contributed a much better known frieze,[85] was a project that, more than any other, epitomized the Wiener Werkstätte's ideal of a totally designed environment. It was natural, then, that Jungnickel would thereafter continue to be active in the Wiener Werkstätte, designing wallpaper and postcards. In 1909, he created a sequence of ten color woodcuts of animals that two years later earned him a prize at the International Art Exhibition in Rome. That same year, 1911, he accepted a professorship at Frankfurt's Kunstgewerbeschule, a post which he kept for scarcely more than a year. Print cycles on animal or nature

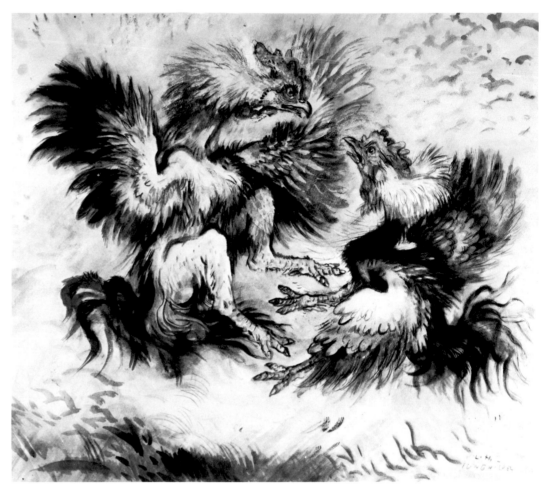

Figure 42 **Ludwig Heinrich Jungnickel** Fighting Roosters. After 1939.

themes continued to appeal to him, and between 1917 and 1922, he published series on animal fables (Figure 41), an Italian journey, and Vienna's famed Spanish Riding School.[86] With the coming of the Nazi regime, his work was branded "degenerate," and in 1939 he emigrated to Yugoslavia. "To a man who is on a first-name basis with nature, such nonsense makes no sense," he said of the political situation in Austria. Jungnickel's years as a refugee were difficult, and he was reduced to selling his sketches in coffeehouses to get by.[87] It was not until 1952 that he returned to Austria.

"Through animals one sees deep, because they are the highest form of nature, mankind included. For us, the animal is the bridge to greater nature."[88] Jungnickel quite clearly took an unusual route to the spiritual core of the natural world, for animals dominate much of his work. The animal had, of course, long held a venerable position in Austrian art. Jungnickel took the Biedermeier propensity to glorify the "lower" life forms and carried it to an Expressionist extreme.

Jungnickel's early work bears the firm stamp of the Jugendstil, perhaps acquired during his years in Munich. At the

Figure 43 **Oskar Kokoschka** Reclining Woman. Ca. 1910.

Kunstgewerbeschule in Vienna he learned a technique in which hand-cut stencils, one for each color, were used with spray paint to build an image.[89] This training accentuated the predilection for stylization that dominated most of his initial efforts. The Expressionism of Schiele and Kokoschka gradually turned him away from pattern. A watercolor such as his *Female Nude with Back Turned* (Figure 44), with its pastel dabs of paint defining form and hinting at character, is clearly influenced by Schiele, while his *Port of Rotterdam* (Figure 46) bears a marked resemblance to some of Kokoschka's landscapes. In the heyday of Ex-

pressionism it was difficult to avoid the human figure, but Jungnickel maintained his unique approach. Once at a party he is said to have become enthralled by the appearance of a young woman, whom he excitedly approached. "I would love to draw you!" he exclaimed. "You look just like a monkey."[90]

Jungnickel eventually returned to portraying animals almost exclusively. Now, for the first time, he had developed the artistic means to do justice to the animal personality. With a varied repertoire of techniques, he could capture both the ferocity of a tiger and the softness of its fur (Plate 28). He found in animals the emotional depth and range

that other artists found in people, and as such his oeuvre belongs to a special chapter of Expressionism.

Oskar Laske

If Jungnickel, in his fashion, carried on the 19th-century practice of animal painting, Laske's contribution can be seen as a continuation of the *veduta* tradition. Although Laske had always enjoyed drawing, he did not decide to become a professional artist until he was in his thirties. Before that he had trained to become an architect at the Academy under Otto Wagner (1841-1918).[91] The turn of the century was an interesting time to be in Vienna, but Laske recalled

Figure 45 **Egon Schiele** Girl with Black Hair. 1911.

Figure 44 **Ludwig Heinrich Jungnickel** Female Nude with Back Turned. 1919.

that he was not overly impressed by the novel aesthetic developments: "With the greatest excitement we marvelled at the new age in art. . . . But already I suffered indescribably as an academician and neither wanted to nor could go along with all these unsightly new things. By luck and good sense this badly produced stuff did not last long."[92] Perhaps it was the Secessionsstil influence that made him dissatisfied with his architectural work. In any case, when he exhibited his "amateur" watercolors at the Hagenbund[93] in 1905, they were well received, and, encouraged by this, he gradually abandoned architecture. He adapted

quickly to a new, leisurely life-style that allowed plenty of time for travel, and in the manner of his 19th century predecessors, he brought back "views" of all he had seen. He, too, was excited by the exotic, be it discovered in remote regions of the Austrian Empire or in the bazaars and mosques of Eastern lands. An officer in the first world war, he was sent to the front as an artist to record the battles. The opportunity for frequent travel was the only positive aspect of his war experience. Laske remained a wanderer all his life, though Austria was always his home. Much of his work was geared to an intimacy of scale that made it well suited for publication, and he

produced a number of print cycles and book illustrations.

Thematically, Laske's creations fall into two categories: scenic descriptions and illustrative allegories. Technically, he generally used watercolor for the former and reserved oil for the latter. In his prints, the two subject types overlap. His approach, in most cases, was to create a broad overview incorporating a complex of moving and stationary forms. The quick fluidity of watercolor was ideally suited to this purpose, for it allowed the artist to block in structural masses and then suggest details with almost abstract strokes (Figure 7). In his oils, where storytelling often dominates,

Figure 46 **Ludwig Heinrich Jungnickel** Port of Rotterdam. 1934 or earlier.

Figure 47 **Ludwig Heinrich Jungnickel** Flowering Trees at the Wörthersee.

the interrelationship between the individual "characters" becomes more intriguing as we try to "figure it all out" (Plate 30 and Figure 49). The genius of the best of these works lies in the artist's ability to incorporate minute details in a monumentally effective whole. In contrast to the intricacy of many of Laske's paintings, his etchings can be unexpectedly serene. Even complicated compositions are subdued by the technical considerations of line and tone.

Alfred Kubin

Alfred Kubin, like Laske, only came to realize slowly that he was destined to be an artist. His childhood was an unhappy one in which both his mother and his stepmother died and his father, somehow blaming the son for their misfortunes, rejected him cruelly. Having twice flunked out of school, Kubin was at the age of fifteen apprenticed to a photographer. For a while he enjoyed processing the magical images of faraway places that were sent to the studio, but after a time he lost interest. Unsure of what to do with himself, he decided in 1897 to join the army. Although he found the military routine soothing, he became violently ill after eighteen days, falling into a sort of coma that lasted several months. Convalescing at home, he amused himself by copying pictures from magazines, and a friend of the family suggested he try art school. So in the spring of 1898 he departed for Munich, and after two years of private instruction he was admitted to the Academy there.

Kubin was stimulated by the creative environment in Munich, and his work began to attract favorable attention. By 1902, he had been given his first one-man show at the Galerie Cassirer in Berlin. The following year, a portfolio reproducing a selection of his drawings in facsimile was published.[94] All seemed to be going well, and Kubin's joy was complete when he met a young woman

Figure 48 **Oskar Kokoschka** London, Tower Bridge. 1925.

whom he thought he would marry. However, once again tragedy entered the artist's life. The woman became sick suddenly, and ten days later she was dead. Kubin, heartbroken, met another woman who consoled him, and in September 1904, they were wed. In 1906, he bought the castle Zwickledt near Schärding on the Inn. This building, actually more like a large country house, would remain Kubin's home base for the rest of his life, though he continued to make excursions to various European cities. The impact of his father's death in 1907 disrupted his work, and he was unable to concentrate for most of the following year. Discovering that at this point he could communicate more easily in words, he wrote a novel, *Die andere Seite* (The Other Side). He illustrated it immediately, and the text with

its accompanying pictures was published in 1909. The book marked the beginning of his career as an illustrator, a career he adapted to his own inclinations, selecting those books that had personal meaning for him and then using the literary work merely as a point of departure. By writing his novel, he had resolved many of the conflicts that had heretofore troubled him, and thereafter there were few radical changes in his art.

Kubin was, especially as a young man, plagued by a demonic vision that distorted his perception of reality (Figures 50 and 51). By formulating a symbolic realm based solely on personal associations, he severed allegory most emphatically from its function as conveyor of universally understood truths. The mind of the artist wanders unbridled in the resul-

tant drawings, which make no effort toward accessibility.

In his early works, Kubin used a spray technique not unlike that employed by Jungnickel. However, he did not confine these delicate mists to block forms, but rather explored nuances of tone. A trip to Paris in 1905 made him conscious of the lack of color in his work, and for a time he turned to tempera (Plate 11). In Vienna, he had been introduced to the popular "trick" of mixing pigment with glue to achieve luminosity (Plate 29).[95] He was, however, made uneasy because his friends seemed to prefer his older, darker pieces. Confused by conflicting impulses, he sought refuge behind the lenses of a microscope. Fascinated by the fragile plant and animal forms he saw there, he discarded the recognizable object and followed a course of

Figure 49 **Oskar Laske** The Plague: Dance of Death. 1912.

virtual abstraction. He quickly became bored by the emptiness of this endeavor, however, and turned instead to mimicking the flat forms that were gaining popularity in France and Germany.

Kubin was being pulled in too many directions, and the hiatus that ended with the writing of *Die andere Seite* no doubt had aesthetic as well as personal origins. The lesson Kubin learned from the entire experience was "that it is not only in the bizarre, exalted or comic moments of our existence that the highest values lie, but that the painful, the indifferent and the incidental commonplace contain the same mysteries."[96] Thereafter his imagery became less eerie, though he projected a peculiar undertone in even the most mundane scenes. Seemingly respectable characters—for example, those one might encounter in a department store (Figure 54)—only partly conceal their lunacy of purpose, which the artist betrays by his juxtaposition of telling details.

Kubin once again banished strong color from his drawings,[97] perfecting a network of line that proved not only more effective without painterly distractions, but better suited to the mechanical reproduction processes involved in his illustration assignments. He often did preliminary pencil studies of exceptional eloquence (Figure 53), but as he considered only the final ink rendering valid, these were not always preserved. He narrowed his repertoire to a limited set of tools with which he felt comfortable: pencil, ink, light color washes and a very particular kind of paper. For years he used the backs of maps which his father, a surveyor, had in copious supply (Figure 55). When he finally ran out of this *Katasterpapier*,[98] he was thrown into a temporary panic until he located a suitable substitute.

Despite his fling with experimentation, Kubin managed to maintain the independence of a hermit. Of his experi-

Figure 50 **Alfred Kubin** Plague. 1902.

Figure 51 **Alfred Kubin** The Coat. Ca. 1903.

Figure 52 **Alfred Kubin** Water Gate. 1933.

Figure 53 **Alfred Kubin** Horses Following Ali, the White Stallion. Ca. 1932.

ences in France he writes, "The Impressionists, of course, made a strong impression on me . . . for my own purposes, however, they had no great significance; in my eyes they were not dreamlike enough, and yet the facility with which they expressed themselves delighted me."[99] Though he was a founding member of the Blaue Reiter, Kubin was equally unaffected by the German avant-garde. "The more abstract, abbreviated and crude the

forms became, the quicker I became tired of them. In my own work, I could not prevail upon myself to hazard on new experiments what I had already attained, by abandoning the intimate, organically related subtleties that I had spent so much effort in learning to portray."[100]

Kubin's novel *Die andere Seite* is about a dream kingdom constructed by a man of enormous wealth who loathes progress. The concept of "a place of asylum for

those who are disgusted with modern culture"[101] echoes the Biedermeier skepticism of Nestroy. For this magical land is actually a thinly disguised caricature of Austria. The narrator, an artist who one can assume speaks for Kubin, would like to count himself among the "dream people" whose "highly developed sense organs . . . enable their possessors to perceive relationships in the world of the individual that simply do not exist for the average person."[102]

Figure 54 **Alfred Kubin** The Department Store. Ca. 1922.

However, he is well aware that these people, by renouncing the horrors of modern civilization, have rejected its benefits as well. They seem foolish and frumpy and, worst of all, fraudulent. Still, when progress, personified appropriately by an American, invades this remote territory, the narrator cannot side with the newcomer. He is trapped between two opposing forces which, at first specific, become universal. "Attraction and repulsion, the poles of the earth

with their currents, the alternation of the seasons, night and day, black and white—these are the battles."[103] The ability to perceive both sides has forced the artist into a position of eternal alienation.

In essence, Kubin's dilemma is not unlike that of many Austrian artists. In spite of all their wandering, they remained forever Austrian, and could not altogether fall in with the schools and movements encountered abroad. And,

in spite of all that was Austrian in them, they remained aliens in their own land as well. Aesthetic trends that animated the rest of Europe seeped only slowly into Austria, and resurfaced there piecemeal or in translation. Romanticism, Biedermeier realism, Impressionism, Art Nouveau, Symbolism and even German Expressionism fueled the Austrian imagination but did not overwhelm it. Attempts on the part of Vienna's educational institutions to coerce compliance with an estab-

Figure 55 **Alfred Kubin's Katasterpapier**.

lished style were equally ineffectual.

Such variety leads to freedom from convention. The Austrian Expressionists thereby attained an independence which facilitated the most direct expression of their inner feelings. "Art always remains exactly the same: art," Schiele wrote in 1909. "Therefore there is no new art. There are new artists. . . . The new artist is and must be absolutely himself. He must be a creator and he must construct an unprecedented foundation, all alone, without utilizing anything of the past or present. . . . Formula is his antithesis."[104]

It is often forgotten that art must go beyond prescribed rules of form and technique, that the ideal of art may remain absolute, but the means thereto are ever changing. "To the time its art, to art its freedom" was the inscription over the Secession entrance.[105] This was not just a condemnation of stale Historicism, or a promotion of any one contemporary movement. It may be interpreted as a plea for the freedom of art from time— for the timelessness of art. "There is no modern art. There is just one art, and it is eternal."[106]

Figure 56 **Alfred Kubin** A Gentle Death. Ca. 1937.

NOTES AND BIBLIOGRAPHY

1 Calvin Tomkins, "The Art World—Communication from Within," *The New Yorker*, LVI:46 (January 5, 1981), p. 67.

2 Otto Kallir's original surname was Nirenstein, but in 1933 he reinstated an old family name, Kallir. For the sake of continuity, he retained the hyphenated name Kallir-Nirenstein until 1939, when emigration made thoughts of continuity superfluous.

3 Richard Lanyi was a bookdealer in Vienna who issued publications from time to time and is best remembered for his Schiele publications.

4 Otto Nirenstein, *Egon Schiele—Persönlichkeit und Werk* (Berlin, Vienna; Leipzig: Paul Zsolnay Verlag, 1930).

5 Most of the contents of the Altenberg room were later donated to the Historisches Museum der Stadt Wien.

6 Otto Kallir, "Richard Gerstl (1883-1908)—Beiträge zur Dokumentation seines Lebens und Werkes," *Mitteilungen der Österreichischen Galerie*, XVIII:64 (1974), p. 125. Hereafter referred to as *Gerstl*.

7 With the advent of World War II, Gerstl's work faded from view. Naturally, it was regarded as degenerate by the Nazis and could not be exhibited in Austria. The large size of many of the canvases, and the relatively small number of surviving works (scarcely more than 60), made it impossible to export enough pieces to establish the artist's reputation abroad. After the war, Kallir, still unable to undertake the task of shipping so many big paintings to New York, sold them to another gallery in Vienna. To this day, the majority of Gerstl's work remains in the hands of a few individuals, and has rarely been exhibited outside Austria. Gerstl achieved international recognition gradually, in conjunction with the general rediscovery of Austrian art, and mainly on the basis of the few paintings in Viennese museums.

8 As an adolescent, Kallir published three books on aviation, of which he was the author of two: Otto Nirenstein, *Geschichte der Luftschiffahrt* (Vienna: H. Engel & Sohn, 1909); Christoph Martin Wieland, *Aeronautische Schriften* (Vienna: Verlag der "HP-Fachzeitung für Automobilismus und Flugtechnik," 1913); Otto Nirenstein, *Luftfahrt im alten Wien* (Vienna: Verlag des k.k. Österreichischen Flugtechnischen Vereines, 1917).

9 After Vita Künstler took over the Neue Galerie, she continued to hold exhibitions of work by artists who had not been banned by the Nazis. After 1942, the war made exhibitions completely impossible, but in July 1945, still amid the wreckage of the bombed city, the gallery reopened with a show called "Indestructible Vienna." Dr. Künstler had managed to preserve much of the old inventory throughout the war, and she remained in charge of the gallery's activities, in partnership with Kallir, until her retirement in 1952. At this point, Kallir's daughter, Evamarie, took over for a few years. In 1956, the gallery was sublet and its name changed to Galerie St. Stephan. Under the name Galerie nächst St. Stephan and after various administrative changes, it continues to this day, although the last official ties with Kallir were severed in 1973.

10 Otto Kallir, *Egon Schiele—Oeuvre Catalogue of the Paintings* (New York: Crown Publishers/Vienna: Paul Zsolnay Verlag, 1966).

11 Otto Kallir, *Egon Schiele – The Graphic Work* (New York: Crown Publishers/Vienna: Paul Zsolnay Verlag, 1970).

12 Kallir, *Gerstl*.

13 Rupert Feuchtmüller, "Vom Lukasbund zur Wiener Spätromantik," *Romantik und Realismus in Österreich*, exhibition in Schloss Laxenburg, 1968, p. 45.

14 *Ibid.*

15 *Ibid.*, p. 47.

16 Ulrich Finke, *German Painting from Romanticism to Expressionism* (London: Thames and Hudson, Ltd., 1974), p. 87.

17 Feuchtmüller, p. 50.

18 The term Biedermeier is itself a composite of the German word for upright or simple, *bieder*, and "Meier," a common surname.

19 Few art movements can be confined to a rigid time frame. Austria recovered slowly from the Napoleonic wars, and Biedermeier arts did not really begin to flourish until the 1820's. Though 1848 was a year of sweeping political changes, Biedermeier art forms lingered on. Aesthetically, 1857 was more pivotal.

20 For a comprehensive summary of Biedermeier arts and crafts, see *Vienna in the Age of Schubert*, exhibition at the Victoria and Albert Museum (London: Elron Press, Ltd., 1979).

21 Hubert Kaut, "Das Österreichische Sittenbild," *Romantik und Realismus in Österreich*, p. 68. The artist's real name was Johann Mathias Ranftl.

22 *Vienna in the Age of Schubert*, p. 22.

23 *Veduta*, the Italian word for view or scene, is a term used to describe an international group of painters who favored such subject matter.

24 There is no entirely satisfactory word for the Austrian variant of French Art Nouveau or German Jugendstil. The most common alternative, Secessionsstil, is likewise inappropriate, because the Vienna Secession comprised an eclectic group of artists who did not favor any one style. All three terms will be used throughout this book to connote a decorative, semi-abstract approach to composition.

25 Fritz Novotny, "Ferdinand Georg Waldmüller," *Romantik und Realismus in Österreich*, p. 58.

26 Alessandra Comini, *The Fantastic Art of Vienna* (New York: Alfred A. Knopf, Inc., 1978), p. 8.

27 Bruno Grimschitz, *Ferdinand Georg Waldmüller—Leben und Werk* (Vienna: Wilhelm Andermann Verlag, 1943), p. 18.

28 *Ibid.*, p. 19.

29 Shortly before Waldmüller's death, the Emperor Franz Josef reinstated his pension at the full amount.

30 Peter Pötschner, "Wege und Erscheinungsformen der nachbiedermeierlichen Landschaft in Wien," *Romantik und Realismus in Österreich*, p. 61.

31 Among such projects, one might list the Church of St. Oswald (1834-37), the Nepomuk Church (1841-46) and the Altlerchenfeld Church (1854-60), all in Vienna.

32 Bruno Grimschitz, *Austrian Painting from Biedermeier to Modern Times* (Vienna: Kunstverlag Wolfrum, 1963), p. 20. Hereafter referred to as *Painting*.

33 Anton Romako, unpublished letter, January 29, 1850 (private collection).

34 Grimschitz, *Painting*, p. 11.

35 Christian M. Nebehay, ed., *Gustav Klimt Dokumentation* (Vienna: Verlag der Galerie Christian M. Nebehay, 1969), p. 135.

36 The foundations for the Secession building were laid on April 28, 1898, and the first exhibition there was held in November of the same year. Construction of the Künstlerhaus, on the other hand, had taken five years (1865-1870). Before that, four years had to be spent simply accumulating sufficient funds.

37 Gustav Klimt and Franz Matsch were given the commission for the University paintings in 1894, subject to the approval of final studies, which were not submitted unitl 1898. The work was to be split between the two painters, with Klimt doing panels on *Philosophy* (Novotny/Dobai 105), *Medicine* (Novotny/Dobai 112) and *Jurisprudence* (Novotny/Dobai 128).

38 See Klimt's *Portrait of Joseph Pembauer*, 1890 (Novotny/Dobai 58) and *Love*, 1895 (Novotny/Dobai 68).

39 Klimt's gold period reached its peak with such paintings as the *Portrait of Adele Bloch-Bauer I*, 1907 (Novotny/Dobai 150) and his famous *The Kiss*, 1907/08 (Novotny/Dobai 154). However, it is interesting to note that, reaching this ultimate penet-

ration of metallic color, the artist simultaneously began searching for a new approach.

40 Fritz Novotny and Johannes Dobai, *Gustav Klimt* (Salzburg: Verlag Galerie Welz, 1967), p. 345. Dobai considers this the first Klimt painting to evidence the artist's rejection of the gold style.

41 The Secession's eighth exhibition, in 1900, was devoted entirely to crafts, and included representative pieces from Paris ("Maison Moderne") and Glasgow (Charles Rennie Mackintosh, Margaret McDonald, Herbert and Frances McNair), as well as contributions by Henry van de Velde and C. R. Ashbee.

42 The mural itself graced the Hall of the Academy of Sciences in Athens, Greece.

43 Alois Gerstl, "Biographische Aufzeichnungen über Richard Gerstl," *Gerstl*, p. 140. Out of a sense of propriety, Alois Gerstl omitted the second verb, but it may be assumed from context.

44 From the sketchy information available, there is no indication that Gerstl suffered the financial deprivation that so plagued Schiele, and his indifference to all aspects of the "commercial" art world would have been less tenable had he been forced to earn a living by painting. Victor Hammer (*Gerstl*, pp. 142-144) corroborates this opinion, and recalls that Gerstl's mother encouraged her son's artistic ambitions.

45 Gerstl spent the summers of 1900 and 1901 studying in Nagy-Banya with the Hungarian painter Simon Holosy, a teacher of much more liberal persuasion than Griepenkerl.

46 Nicholas Powell, *The Sacred Spring* (Greenwich, Connecticut: New York Graphic Society, 1974), p. 164.

47 H. H. Stuckenschmidt, *Arnold Schönberg (New York: 1977), pp. 88-89.*

48 Gerstl, p. 139.

49 *Ibid.,* p. 138.

50 Kallir, *Gerstl*, p. 132.

51 Victor Hammer, "Erinnerungen an Richard Gerstl," *Gerstl*, p. 143.

52 Eberhard Freitag, "Schönberg's Self-Portraits," *Journal of the Arnold Schönberg Institute*, II:3 (June, 1978), p. 168. Hereafter referred to as *Schönberg*.

53 Arnold Schönberg, "Painting Influences," *Schönberg*, p. 238.

54 The date of Schönberg's first personal encounter with Kandinsky has been variously given as 1906, 1909 and 1911. Harvard University graduate student Pamela Hoyle, in an unpublished paper, "Kandindsky and Schönberg: Were There Mutual Influences?" (Fall, 1979), has presented fairly convincing evidence in favor of the latest date.

55 Wassily Kandinsky, "The Paintings of Schönberg," *Schönberg*, p. 184.

56 Ludwig Goldscheider, ed., *Kokoschka* (London: Phaidon Press, Ltd., 1963), p. 10.

57 Stephan Steinlein, "Ludwig Heinrich Jungnickel-München," *Deutsche Kunst und Dekoration*, XVII (November, 1905), p. 118. Kokoschka claimed to have instituted this avant-garde teaching method himself, but the above article, written the year he entered the Kunstgewerbeschule, clearly indicates that Roller was responsible.

58 Peter Vergo, *Art in Vienna 1898-1918* (London: Phaidon Press, Ltd., 1975), p. 189.

59 Karl Kraus (1874-1936) is best remembered for his magazine *Die Fackel*, a sarcastic commentary on life in Vienna from the years 1899-1936, which after 1911 was a one-man production. Peter Altenberg (pseudonym of Richard Engländer; 1859-1919) may be considered one of the century's first conceptual artists. His achievement lay as much in his bohemian presence as in his work, and his writing often drew its meaning from juxtaposition with a telling visual image.

60 *Dents du Midi* (Wingler 30).

61 See *Bessie Loos* (Wingler 31), *Conte Verona* (Wingler 32) and *Duchess of Rohan-Montesquieu* (Wingler 33).

62 The periodical *Der Sturm* was founded by Herwarth Walden in 1910, and two years later supplemented by a gallery of the same name. Walden's program was modern, and encompassed not just the German Blaue Reiter painters, but also the Italian Futurists, French Fauves and Cubists.

63 Although there is some uncertainty as to the exact date of this painting, it is currently understood to have been executed before the artist's war experiences. For a detailed discussion of the work and its significance, see Angelica Zanders Rudenstine, *The Guggenheim Museum Collection: Paintings 1880-1945*, Vol. II, pp. 426-431.

64 Paul Westheim, *Oskar Kokoschka* (Potsdam-Berlin: Verlag Gustav Kiepenhauer, 1918).

65 During one of Kokoschka's 1924 exhibitions at Otto Kallir's Neue Galerie, a painting was slashed by a vandal. Adolf Loos advised the artist to make the most of the publicity value of this incident. Kallir's wife recalls that Loos arranged for Kokoschka to flee Vienna in disgust, though the artist himself was somewhat reluctant to go. Loos and Kallir actually had to watch over him to ensure that he boarded the train at the appointed hour.

66 In 1934, Kokoschka settled in Prague, where he stayed until 1938, when Nazi takeover seemed imminent. He spent the war years primarily in England, and lingered on there afterward, though the frequency of his travels began to increase.

67 Edith Hoffmann, *Kokoschka: Life and Work* (London: Faber, Ltd., 1947), p. 26.

68 Goldscheider, p. 14.

69 The core group of Die Brücke, founded in 1905, included Ernst Ludwig Kirchner, Erich Heckel, Karl Schmidt-Rottluff and Fritz Bleyl; in 1906 they were joined by Emil Nolde and Max Pechstein; in 1910 by Otto Müller. They disbanded in 1913.

70 In 1909, a group of artists which included Wassily Kandinsky, Alfred Kubin and Alexej Jawlensky left the Munich Secession to found the Neue Künstlervereinigung. In 1911, this new organization, too, proved unsatisfactory to some of its members, and Kandinsky, Kubin, Franz Marc and Gabriele Münter left. The first exhibition of the Blaue Reiter, that same year, also included works by Jawlensky, August Macke and others.

71 Oskar Kokoschka, "Von der Natur der Gesichte," *Oskar Kokoschka Schriften 1907-1955*, Albert Langen and Georg Müller, eds., (Munich: Albert Langen-Georg Müller, 1956), p. 337.

72 Goldscheider, p. 7.

73 Van Gogh's influence is especially evident in *The Artist's Room in Neulengbach*, 1911 (Kallir 149). For a summary of early influences on Schiele, see Alessandra Comini, *Egon Schiele's Portraits* (Berkeley-Los Angeles: University of California Press, 1974), pp. 53-57.

74 See *Mother and Death*, 1911 (Kallir 135), *Agony*, 1912 (Kallir 157) and *Conversion I*, 1912 (Kallir 158).

75 Egon Schiele, letter to an unnamed woman, 6.VII.1909, *Egon Schiele—Leben, Briefe, Gedichte*, Christian Nebehay (Salzburg-Vienna: Residenz Verlag, 1979), p. 111.

76 Heinrich Benesch, letter to Schiele, 16.XI.1910, *Egon Schiele—Leben, Briefe, Gedichte*, p. 138. Benesch, a railroad inspector who did not have a large income for art collecting, had recently met Schiele, and was so taken with his work that, in spite of his wife's protests, he begged the artist to give him any unwanted scraps or sketches which would otherwise be burned. Benesch became one of Schiele's most ardent supporters, and his son Otto grew up to be an art historian and was from 1947 to 1962 Director of the Albertina in Vienna. In 1913, Schiele painted a double portrait of father and son (Kallir 175).

77 *Die Traumbeschaute*, a 1911 watercolor of a masturbating woman, was reproduced in a portfolio of erotic works.

78 See Klimt's *Hope I*, 1903 (Novotny/Dobai 129). *Procession of the Dead*, 1903 (Novotny/Dobai 131), *The Three Ages of Woman*, 1905 (Novotny/Dobai

141) and *Death and Life*, before 1911 (Novotny/Dobai 183).

79 Religious themes such as the *Flight from Egypt* (Wingler/Welz 55), the Annunciation (Wingler/Welz 56) and the *Pietà* (Wingler/Welz 68) turn up in Kokoschka's early prints and in two paintings (Wingler 52, 53). In 1916, he did an entire group of lithographs on *The Passion* (Wingler/Welz 78-83). His 1918 drypoints *Orpheus and Eurydice* (Wingler/Welz 120-125) evidence an interest in mythology which resurfaces in later prints and paintings such as his triptych on the Prometheus saga (Wingler 362-364).

80 See *The Self Seers I*, 1910 (Kallir 113), *The Hermits*, 1912 (Kallir 159), *Self-Portrait with Saint*, 1913 (Kallir 177) and *Death and the Maiden*, 1915 (Kallir 207).

81 See *Madonna*, 1911 (Kallir 134), *Cardinal and Nun*, 1912 (Kallir 156), *Resurrection*, 1913 (Kallir 176) and *Transfiguration*, 1915 (Kallir 206).

82 Schiele depicts himself as the husband in *The Family*, though the woman is a model, not his wife, and the infant is not readily identifiable. Clearly the artist, who had been married for over two years when he began the painting, was meditating on the wedded state, which in his case was not entirely blissful. One cannot know what discussions he and Edith may have had about children; she became pregnant several months after the painting was finished.

83 Jungnickel, Laske and Kubin have been singled out for discussion here because of their highly idiosyncratic approaches. Two larger groups of artists who have been deliberately neglected are the design-oriented faction which surrounded Klimt and the Wiener Werkstätte, and the Expressionists who came to prominence in the period between the two world wars. For additional information on the former, see Powell's *The Sacred Spring* and Vergo's *Art in Vienna*. A basic introduction to the latter may be obtained from Kristian Sotriffer's *Modern Austrian Art—A Concise History* (New York-Washington: Frederick A. Praeger, 1965).

84 In 1904, Adolphe Stoclet commissioned the Wiener Werkstätte to create a home for him and his family in Brussels. The entire project, unencumbered by any monetary restrictions, was overseen by Josef Hoffmann and designed down to the last teaspoon. It was not completed until 1924.

85 Klimt's *Stocletfries*, 1909/11 (Novotny/Dobai 153) was installed by the Wiener Werkstätte, according to the artist's designs, in the dining room of the house.

86 *Tiere der Fabel* (Vienna: Verlag der Gesellschaft für vervielfältigende Kunst, 1917); *Italienisches Skizzenbuch* (Vienna-Berlin-Munich-Leipzig: Rikola Verlag/Verlag Neuer Graphik, 1922); *L. H. Jungnickel—Studien aus der Spanischen Hofreitschule in Wien* (Vienna: Haybach-Verlag, 1922).

87 As recalled by Fanny Kallir.

88 L. H. Jungnickel, "Das Tier in Kunst und Kunsthandwerk," *Der Tierfreund 81*, II (1926), p. 17.

89 Marian Bisanz-Prakken, "Ludwig Heinrich Jungnickel," *Oskar Laske, Ludwig Heinrich Jungnickel, Franz v. Zülow*, exhibition at Graphische Sammlung Albertina, 1978, p. 64.

90 As recalled by Fanny Kallir.

91 Otto Wagner was one of the most significant architects in Vienna at the turn of the century. Both a member of the Secession and a professor at the Academy, he bridged the gap between Ringstrasse Historicism and Modernism.

92 Marian Bisanz-Prakken, "Oskar Laske," *Oskar Laske, Ludwig Heinrich Jungnickel, Franz v. Zülow*, p. 14.

93 The Hagenbund was founded in 1900 as an alternative to both the Künstlerhaus and the Secession. It was named after the proprietor of the Blaues Freihaus, a café where many of the original members hung out. Heinrich Lefler was the first president; Laske joined in 1907.

94 *Alfred Kubin* (Munich: Hans von Weber, 1903).

95 Kubin recalled that Koloman Moser had taught him this technique, which was also used by (among others) Egon Schiele.

96 Alfred Kubin, "Alfred Kubin's Autobiography," *The Other Side*, Denver Lindley, trans., (New York: Crown Publishers, 1967), p. xxxvii.

97 For a time Kubin worked only in black and white, but eyestrain prompted him to re-introduce light veils of color.

98 Kubin claims he exhausted his supply of *Katasterpapier*, which translates literally as "land registry paper," in 1915, though the evidence of actual works on this paper suggests a later date.

99 Kubin, "Alfred Kubin's Autobiography," p. xxxii.

100 *Ibid.*, p. xliii.

101 Kubin, *The Other Side*, p. 13.

102 *Ibid.*, p. 14.

103 *Ibid.*, p. 27.

104 Egon Schiele, draft of an essay, "Neukunstler." XII.1909, *Egon Schiele—Leben, Briefe, Gedichte*, p. 112.

105 *Der Zeit ihre Kunst, der Kunst ihre Freiheit.*

106 Arthur Roessler, ed., *Briefe und Prosa von Egon Schiele* (Vienna: Verlag der Buchhandlung Richard Lanyi, 1921), p. 19.

The following oeuvre catalogues are used to identify works of art throughout this book. References give the author's name followed by the number assigned to the work in question.

Frodl, Gerbert. *Hans Makart—Monographie und Werkverzeichnis*. Salzburg: Residenz Verlag, 1974.

Gallwitz, Klaus. *Max Beckmann—Katalog der Druckgraphik: Radierungen, Lithographien, Holzschnitte, 1901-1948*. Karlsruhe: Badischer Kunstverein, 1962.

Grimschitz, Bruno. *Ferdinand Georg Waldmüller*. Salzburg: Verlag Galerie Welz, 1957.

Hevesi, Ludwig. *Rudolf Alt—Sein Leben und sein Werk*. Vienna: Verlag von Artaria & Co., 1911.

Kallir, Otto. "Richard Gerstl (1883-1908)—Beiträge zur Dokumentation seines Lebens und Werkes." XVIII:62 (1974) *Mitteilungen der Osterreichischen Galerie*. pp. 125-193.

———. *Egon Schiele—Oeuvre Catalogue of the Paintings*. New York: Crown Publishers/Vienna: Paul Zsolnay Verlag, 1966.

———. *Egon Schiele—The Graphic Work*. New York: Crown Publishers/Vienna: Paul Zsolnay Verlag, 1970.

Novotny, Fritz. *Der Maler Anton Romako*. Vienna-Munich: Verlag Anton Schroll & Co., 1954.

———, and Johannes Dobai. *Gustav Klimt*. Salzburg: Verlag Galerie Welz, 1967.

Raabe, Paul. *Alfred Kubin—Leben, Werk, Wirkung*. Hamburg: Rowohlt Verlag, 1957.

Rathenau, Ernst. *Kokoschka Handzeichnungen*. Berlin: Ernst Rathenau Verlag, 1935.

———. *Der Zeichner Kokoschka*. New York: Ernest Rathenau, 1961.

———. *Oskar Kokoschka Handzeichnungen, 1906-1965*. New York: Ernest Rathenau, 1966.

Strobl, Alice. *Gustav Klimt—Die Zeichnungen 1887–1903*. Salzburg: Verlag Galerie Welz, 1980.

Weixlgärtner, Arpad. *August Pettenkofen*. Vienna: Gerlach & Wiedling, 1916.

Wingler, Hans Maria. *Oskar Kokoschka—Das Werk des Malers*. Salzburg: Verlag Galerie Welz, 1956.

———, and Friedrich Welz. *Kokoschka—Das druckgraphische Werk*. Salzburg: Verlag Galerie Welz, 1975.

LIST OF ILLUSTRATIONS

1 **Richard Gerstl** Self-Portrait. Ca. 1906. Pen and ink on paper. Estate stamp, verso. 18⅛″ × 12⅜″ (46 × 31.5 cm). Kallir 61. Private collection.

2 **Ludwig Heinrich Jungnickel** Portrait of Otto Kallir. Ca. 1920. Drypoint on yellowish paper. 3⅝″ × 3½″ (9.3 × 9 cm).

3 **Photograph of the Entrance to the Neue Galerie** Ca. 1923.

4 **Photograph of the Richard Gerstl Estate Stamp.**

5 **Oskar Kokoschka** The Publisher Dr. Robert Freund I. Ca. 1914. Oil on canvas. 27⅞″ × 18⅞″ (58 × 48 cm). Wingler 89. In 1949, the painting was restored to its original condition by the artist.

6 **Rudolf von Alt** St. Stephen's Cathedral. 1832. Oil on canvas. Signed and dated, lower center. 18⅛″ × 22¾″ (46 × 58 cm). Hevesi, Plate 1. Österreichische Galerie, Vienna.

7 **Oskar Laske** St. Stephen's Cathedral: Post-War Restoration. 1950. Watercolor on heavy drawing paper. Signed and dated, lower right. 15⅜″ × 21⅜″ (39 × 54.3 cm). Private collection.

8 **Peter Altenberg** The Eighteen-Year-Old Empress Elisabeth. Postcard. Initialed, center right, and titled, lower left. Inscribed, upper half: ''Du wusstest nichts und hofftest Alles. Später wusstest Du Alles und hofftest nichts.'' (You knew nothing and hoped for everything. Later, you knew everything and hoped for nothing).

9 **Thomas Ender** Mödling with Both the Old Churches. Watercolor on paper. 10¼″ × 16⅛″ (26 × 41 cm). Collection Dr. Rudolf Kallir.

10 **Moritz Michael Daffinger** Snowberries. 1835. Watercolor on paper. Signed and dated, lower right. 14¼″ × 9¾″ (36.3 × 24.7 cm). Private collection.

11 **Egon Schiele** Wilted Sunflower. 1912. Tempera and pencil on paper. Signed and dated, lower left. 17¾″ × 11¾″ (45 × 30 cm). Private collection.

12 **Ferdinand Georg Waldmüller** Fruit and Flowers. 1839. Oil on wood. Signed and dated, center left. 25″ × 19¾″ (63.5 × 50 cm). Grimschitz 541. Österreichische Galerie, Vienna.

13 **Egon Schiele** Sunflowers. 1911. Oil on canvas. Signed and dated, lower left. 35½″ × 31¾″ (90.4 × 80.5 cm). Kallir 148. Österreichische Galerie, Vienna.

14 **Egon Schiele** Drying Laundry. 1908. Oil on cardboard. Initialed and dated, lower right. 7¼″ × 7″ (18.5 × 18 cm). Kallir 69.

15 **August von Pettenkofen** Garden in Grünau. 1886. Gouache on paper. Initialed, lower left. 15⅜″ × 10¼″ (39 × 26 cm). Weixlgärtner 770. Private collection.

16 **Anton Romako** Girl on a Swing (Olga von Wassermann). Ca. 1882. Oil on canvas. Signed, lower left. 63″ × 48″ (160 × 121.9 cm). Novotny 314. Smith College Museum of Art, Northampton, Massachusetts; Purchased 1963.

17 **Hans Makart** Clothilde Deor. Ca. 1880. Oil on wood. Signed, lower left. 32¼″ × 26¾″ (82 × 68 cm). Frodl 358. Österreichische Galerie, Vienna.

18 **Egon Schiele** Portrait of Elisabeth Lederer. 1913. Watercolor and pencil on paper. Signed and dated, lower right. 18⅞″ × 11½″ (48 × 29 cm). Private collection.

19 **Gustav Klimt** Seated Woman. 1897-98. Charcoal and mixed media on paper. Inscribed, lower left, by the artist's sister Hermine Klimt: ''Nachlass meines Bruders Gustav'' (Estate of my brother Gustav). 17¾″ × 12″ (45 × 30.5 cm). Strobl 400. Collection David Morgan Yerzy.

20 **Richard Gerstl** Small Street Painting. Oil on cardboard. Estate stamp, verso. 14¼″ × 11½″ (35.3 × 29 cm). Kallir 16. Collection Viktor Fogarassy.

21 **Richard Gerstl** The Sisters (Karoline and Pauline Fey). 1905. Oil on canvas. Inscribed, verso: ''Richard Gerstl IX, Nussdorferstr. 35.'' 68⅞″ × 59⅛″ (175 × 150 cm). Kallir 52. Österreichische Galerie, Vienna.

22 **Richard Gerstl** Self-Portrait in Front of the Stove. Oil on canvas. Estate stamp, stretcher. *Self-Portrait, Study*, verso. 27″ × 21⅝″ (68.3 × 55 cm). Kallir 22. Collection Viktor Fogarassy.

23 **Richard Gerstl** Self-Portrait, Study. Oil on canvas. Estate stamp, stretcher. *Self-Portrait In Front of the Stove*, verso. 27″ × 21⅝″ (68.3 × 55 cm). Kallir 22. Collection Viktor Fogarassy.

24 **Richard Gerstl** Self-Portrait. Ca. 1906. Pen and ink on paper. Estate stamp, verso. 17¾″ × 12⅜″ (45 × 31.5 cm). Kallir 60. Estate of Dr. Otto Kallir.

25 **Richard Gerstl** Self-Portrait. 1908. Wash, pen and ink and charcoal on heavy paper. Inscribed, lower right: ''29.Sept.'' Estate stamp, verso. 15¾″ × 11¾″ (40 × 29.5 cm). Kallir 63. Estate of Dr. Otto Kallir.

26 **Oskar Kokoschka** Savoyard Boy, Standing. 1912. Charcoal and wash on paper. Initialed, lower center. 17½″ × 12⅜″ (44.5 × 31.5 cm). Private collection.

27 **Oskar Kokoschka** Tre Croci Landscape. 1913. Charcoal on paper. Signed, lower right. 14″ × 18″ (35.6 × 45.7 cm). Rathenau (1966) 32. Private collection.

28 **Oskar Kokoschka** The Coast of Naples. 1913. Charcoal on paper. Initialed, lower left. Charcoal sketch, verso. 9¼″ × 12¾″ (23.5 × 32.3 cm). Galerie St. Etienne.

29 **Oskar Kokoschka** Naples, Harbor Scene. 1913. Colored pastel on paper. Initialed, lower left. 10″ ×

13½" (25.5 × 34.5 cm). Rathenau (1966) 30. Estate of Dr. Otto Kallir.

30 **Oskar Kokoschka** Lotte Franzos. 1908-9. Oil on canvas. Initialed, lower right. 44⅞" × 33½" (114 × 85 cm). Wingler 11. The Phillips Collection, Washington, D.C.

31 **Oskar Kokoschka** Sposalizio. 1911 or earlier. Oil on canvas. Initialed, lower left. 41" × 24⅜" (104 × 62 cm). Wingler 67. Allen Memorial Art Museum, Oberlin College, Oberlin, Ohio; Elisabeth Lotte Franzos Bequest, 58.51.

32 **Oskar Kokoschka** Nude with Back Turned. Ca. 1907. Watercolor, crayon, pencil and ink on paper. Initialed, lower center. 17¾" × 12¼" (45 × 31 cm). Rathenau (1935) 10. The Museum of Modern Art, New York; Rose Gershwin Fund.

33 **Oskar Kokoschka** Portrait of a Lady. 1916. Black crayon on white paper. Initialed and dated, lower right. 22¼" × 16⅜" (56.5 × 41.5 cm). Rathenau (1961) 63. The Fogg Art Museum, Harvard University, Cambridge, Massachusetts; Bequest of James N. Rosenberg in Honor of Paul J. Sachs.

34 **Oskar Kokoschka** Mrs. M. (Mary Merson). 1931. Sanguine on yellowish laid paper. Signed, lower right. 17½" × 12⅛" (44.5 × 30.8 cm). Rathenau (1961) 125. Galerie St. Etienne.

35 **Gustav Klimt** After the Rain (Garden with Chickens in St. Agatha). 1899. Oil on canvas. Signed, lower right. 31⅝" × 15¾" (80.3 × 40 cm). Novotny/Dobai 107. Österreichische Galerie, Vienna.

36 **Egon Schiele** Orchard in Spring. 1907. Oil on cardboard. Signed and dated, lower right. 14" × 10" (35.7 × 25.3 cm). Kallir 18. Private collection.

37 **Egon Schiele** Trees in Winter. (Three Trees). 1912. Oil on canvas. Signed and dated, upper left. 31⅝" × 31½" (80.3 × 80 cm). Kallir 160. Private collection.

38 **Egon Schiele** City on the Blue River. 1910. Watercolor and charcoal on paper. Initialed and dated, lower right. 17¾" × 12½" (45 × 31.6 cm). Study for the paintings of the same title (Kallir 140, 141). Private collection.

39 **Egon Schiele** Chapel on a Mountain (Thunderstorm Mountain). Ca. 1910. Oil on canvas, mounted on Masonite. 13⅞" × 25⅞" (35.2 × 65.7 cm). Kallir 121. Private collection.

40 **Egon Schiele** Girl with Blond Hair in Red Dress. 1916. Tempera and pencil on paper. Signed and dated, lower right. 18⅛" × 12⅛" (46 × 31 cm). Private collection.

41 **Ludwig Heinrich Jungnickel** Hinze. Ca. 1917. Gouache, india ink and pencil on Bütten paper. Signed, lower left. 11¾" × 7" (29.8 × 18 cm). Design for the woodcut of the same title (Plate 4 in the

series *Tiere der Fabel*).

42 **Ludwig Heinrich Jungnickel** Fighting Roosters. After 1939. Watercolor on Fabriano Bütten paper. Signed, lower right. 18" × 21½" (45.5 × 54.5 cm).

43 **Oskar Kokoschka** Reclining Woman. Ca. 1910. Watercolor on paper. Initialed, lower right. 11½" × 17" (29.2 × 43.2 cm). Private collection.

44 **Ludwig Heinrich Jungnickel** Female Nude with Back Turned. 1919. Watercolor on yellowish paper. Signed, lower right. Dated in another hand. 16½" × 13¾" (42 × 35 cm).

45 **Egon Schiele** Girl with Black Hair. 1911. Watercolor and pencil on paper. Signed and dated, lower right. 22¼" × 14¼" (56.5 × 36.2 cm). Private collection.

46 **Ludwig Heinrich Jungnickel** Port of Rotterdam. 1934 or earlier. Oil on canvas. Signed, upper left and lower center. Signed and titled on the stretcher. 23⅝" × 31⅞" (60 × 81 cm). Galerie St. Etienne.

47 **Ludwig Heinrich Jungnickel** Flowering Trees at the Wörthersee. Oil on canvas. Signed, lower right. 29¼" × 33⅝" (74 × 85.3 cm). Private collection.

48 **Oskar Kokoschka** London, Tower Bridge. 1925. Oil on canvas. Dated, lower right. Initialed and dated, verso. 30" × 52⅛" (76.2 × 132.3 cm). Wingler 198. The Minneapolis Institute of Arts; Bequest of Putnam Dana McMillan.

49 **Oskar Laske** The Plague: Dance of Death. 1912. Oil on canvas. Signed, titled and dated, lower right. 39½" × 55" (100.3 × 139.6 cm). Private collection.

50 **Alfred Kubin** Plague. 1902. Pen and ink and wash, heightened with white, on *Katasterpapier*. Signed, lower left; titled and dated, lower right. 12⅛" × 15½" (30.8 × 39.6 cm). Graphische Sammlung Albertina, Vienna.

51 **Alfred Kubin** The Coat. Ca. 1903. Pen and ink and wash on *Katasterpapier*. Signed twice, lower right. 12⅛" × 15⅛" (30.8 × 38.3 cm). Graphische Sammlung Albertina, Vienna.

52 **Alfred Kubin** Water Gate. 1933. Pen and ink, watercolor and spray paint on Bütten paper. Signed and dated, lower right; titled, lower left. 16¾" × 13⅜" (42.7 × 34.1 cm). Private collection.

53 **Alfred Kubin** Horses Following Ali, the White Stallion. Ca. 1932. Pencil on yellowish paper. Signed, lower right. Inscribed, upper right: "5." 13½" × 12⅛" (34.5 × 30.6 cm). Drawing for Plate 5 in the portfolio of lithographs *Ali der Schimmelhengst* (Raabe 451). Private collection.

54 **Alfred Kubin** The Department Store. Ca. 1922. Watercolor and ink on *Katasterpapier*. Signed,

lower right. 12⅛" × 15⅞" (30.8 × 40.4 cm). Private collection.

55 **Photograph of the Katasterpapier Used by Alfred Kubin**

56 **Alfred Kubin** A Gentle Death. Ca. 1937. Pen and ink and wash on Bütten paper. Signed, lower right, and titled, lower left. 15½" × 12¼" (39.2 × 31.2 cm). Private collection.

COLOR PLATES

Cover **Egon Schiele** Self-Portrait. 1912. Watercolor and pencil on paper. Signed and dated, lower right. 13¾" × 10" (35 × 25.3 cm). Private collection.

1 **Michael Neder** Cattle Market. 1869. Oil on wood. Signed and dated, lower left. 9¾" × 13½" (24.8 × 30.3 cm). Private collection.

2 **Ferdinand Georg Waldmüller** The Rettenkogel Seen from St. Wolfgang. 1831. Oil on wood. Signed and dated, lower left. 9" × 11⅜" (23 × 29 cm). Grimschitz 290. Private collection.

3 **Ferdinand Georg Waldmüller** Early Spring in the Vienna Woods. 1862. Oil on wood. Signed and dated, lower center. 18½" × 22¾" (47 × 57.7 cm). Grimschitz 968. Private collection.

4 **Rudolf von Alt** Landscape Near Salzburg. Probably before 1850. Oil on canvas. Signed, lower left. 20½" × 31⅛" (52.5 × 79 cm). Collection Dr. Rudolf Kallir.

5 **August von Pettenkofen** Hungarian Hay Wagon. 1857. Oil on canvas, mounted on wood. Signed and dated, lower right. 11" × 19" (28 × 48.2 cm). Collection Dr. Rudolf Kallir.

6 **Hans Makart** The Dream (After the Ball). Ca. 1872. Oil on canvas. Signed, lower right. 62⅜" × 37¼" (158.4 × 94.6 cm). Frodl 185. The Metropolitan Museum of Art, New York; Bequest of Catherine Lorillard Wolfe, 1887; The Catherine Lorillard Wolfe Collection.

7 **Anton Romako** Portrait of the Empress Elisabeth. Ca. 1880. Oil on canvas. Signed, lower left. 23" × 18¼" (58 × 46 cm). Novotny 289. Private collection.

8 **Gustav Klimt** Pale Face. 1907-8. Oil on canvas. 31½" × 15¾" (80 × 40 cm). Novotny/Dobai 156. Private collection.

9 **Gustav Klimt** Pine Forest II. 1901. Oil on canvas. Signed, lower right. 35½" × 35½" (90 × 90 cm). Novotny/Dobai 121. Private collection.

10 **Anton Romako** Gastein Valley in the Fog. 1877. Oil on canvas. Signed, lower left. 16⅝" × 21⅝" (42.2 × 55 cm). Novotny 229. Österreichische Galerie, Vienna.

11 **Alfred Kubin** Plateau Landscape. Ca. 1907. Tempera on heavy paper. Signed, lower right. 10" × 14¼" (25.5 × 36.1 cm). Private collection.

12 **Gustav Klimt** Castle Pond in Kammer on the Attersee. Before 1910. Oil on canvas. 43¼" × 43¼" (110 × 110 cm). Novotny/Dobai 167. Private collection.

13 **Richard Gerstl** Small Garden Painting. Oil on cardboard. Estate stamp, verso. 13⅝" × 13¼" (35 × 34 cm). Kallir 15. Collection Viktor Fogarassy.

14 **Richard Gerstl** Grinzing. Oil on canvas. Estate stamp, verso. 11¾" × 15⅛" (29.7 × 40.2 cm) Kallir 14. Private collection.

15 **Egon Schiele** Mountain Landscape. 1910. Oil on light cardboard. Initialed and dated, lower left. Pencil drawing, *Two Female Nudes*, verso. 15" × 22" (38 × 56 cm). Kallir 119. Collection Mr. and Mrs. Herman Elkon.

16 **Anton Romako** The Weilburg with Cholera Chapel Near Baden. 1885. Oil on wood. Signed, lower left. 5¼" × 7⅛" (13.2 × 18 cm). Novotny 333. Österreichische Galerie, Vienna.

17 **Oskar Kokoschka** Lac d'Annecy II. Ca. 1930. Oil on canvas. 29¾" × 39½" (63 × 80 cm). Wingler 250. The Phillips Collection, Washington, D.C.

18 **Richard Gerstl** Nude in Garden. Ca. 1908. Oil on canvas. Estate stamp, verso. 47¾" × 39" (121.1 × 99 cm). Kallir 48. Estate of Dr. Otto Kallir.

19 **Richard Gerstl** Self-Portrait, Laughing. Oil on canvas, mounted on board. 15⅜" × 12" (39 × 30.4 cm). Kallir 2. Österreichische Galerie.

20 **Egon Schiele** The Red Host. 1911. Watercolor and pencil on paper. Signed and dated, lower right; titled, upper right. 19" × 11⅛" (48.2 × 28.2 cm). Private collection.

21 **Egon Schiele** Moa. 1911. Watercolor on yellowish paper. Signed and dated, center right, and titled, lower left. 18¾" × 12⅜" (47.5 × 31.5 cm). Private collection.

22 **Oskar Kokoschka** Child with the Hands of its Parents. 1909. Oil on canvas. Initialed, upper left. 28⅜" × 20½" (72 × 52 cm). Wingler 23. Österreichische Galerie, Vienna.

23 **Egon Schiele** Girl in Polka Dot Dress. 1911. Watercolor and pencil on paper. Signed and dated, center right. 17" × 11⅞" (43.3 × 30.3 cm). Private collection.

24 **Gustav Klimt** Adam and Eve. 1917-18. Unfinished. Oil on canvas. 68⅛" × 23⅝" (173 × 60 cm). Novotny/Dobai 220. Österreichische Galerie, Vienna.

25 **Oskar Kokoschka** Two Nudes (Dancing Couple). Ca. 1913. Oil on canvas. Initialed, lower center. 48¾" × 34⅝" (124 × 88 cm). Wingler 77. Museum of Fine Arts, Boston; Bequest of Mrs. Sarah Reed Blodgett Platt.

26 **Richard Gerstl** Portrait of the Arnold Schönberg Family. Ca. 1908. Oil on canvas. Signed, lower right. 34⅝" × 43" (88 × 109 cm). Kallir 33. Museum moderner Kunst, Vienna.

27 **Egon Schiele** The Family (Squatting Couple). 1917-18. Oil on canvas. 59" × 63" (149.7 × 160 cm). Kallir 240. Österreichische Galerie, Vienna.

28 **Ludwig Heinrich Jungnickel** Three Tigers. Tempera and charcoal on heavy drawing paper. Signed, lower left. 19⅛" × 22" (48.5 × 56 cm). Private collection.

29 **Alfred Kubin** Dispatching a Treasure. Ca. 1908. Tempera and glue on heavy paper. Signed, lower right. 9⅞" × 14⅛" (25 × 36 cm). Private collection.

30 **Oskar Laske** Ship of Fools (Third Version). 1949. Oil on canvas. Signed, lower right, and titled, lower left. 53½" × 42½" (136 × 108 cm). Collection Alice Steiner.

31 **Oskar Kokoschka** Knight Errant. 1915. Oil on canvas. Initialed, lower right. 35¼" × 70⅛" (89.5 × 178.2 cm). Wingler 105. The Solomon R. Guggenheim Museum, New York.

Plate 1 **Michael Neder** Cattle Market. 1869.

Plate 2 **Ferdinand Georg Waldmüller** The Rettenkogel Seen from St. Wolfgang. 1831.

Plate 3 **Ferdinand Georg Waldmüller** Early Spring in the Vienna Woods. 1862.

Plate 4 **Rudolf von Alt** Landscape Near Salzburg. Probably before 1850.

Plate 5 **August von Pettenkofen** Hungarian Hay Wagon. 1857.

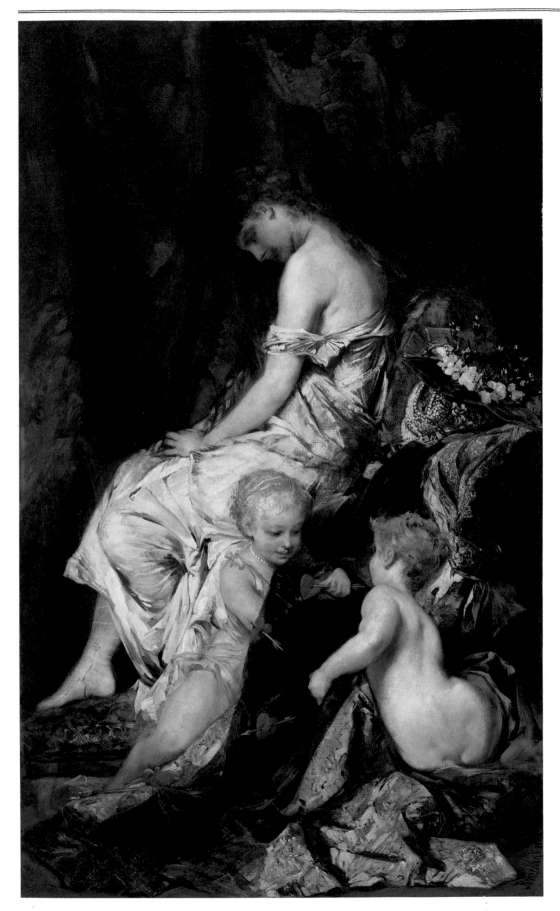

Plate 6 **Hans Makart** The Dream (After the Ball). Ca. 1872.

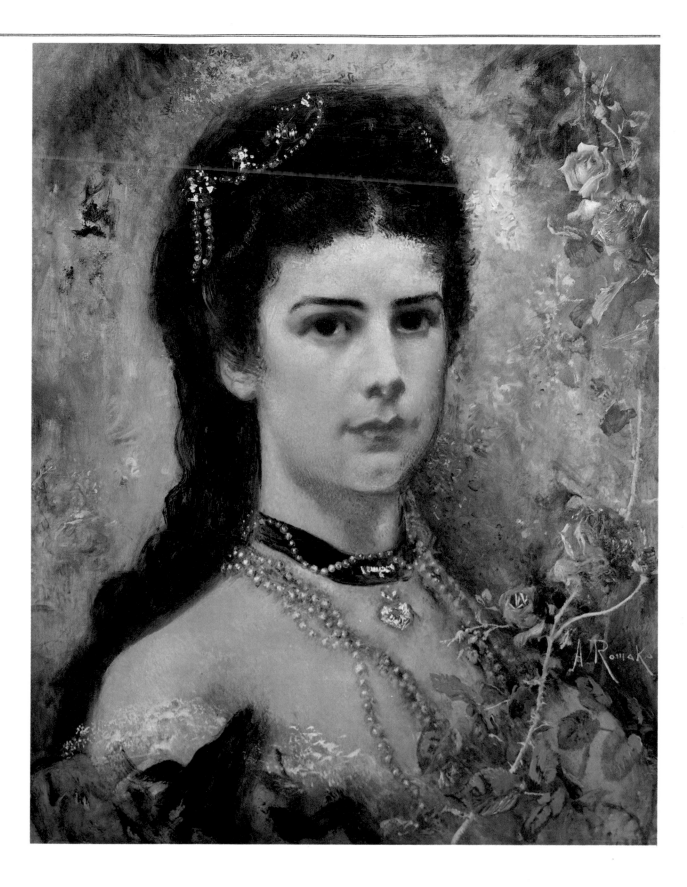

Plate 7 **Anton Romako** Portrait of the Empress Elisabeth. Ca. 1880.

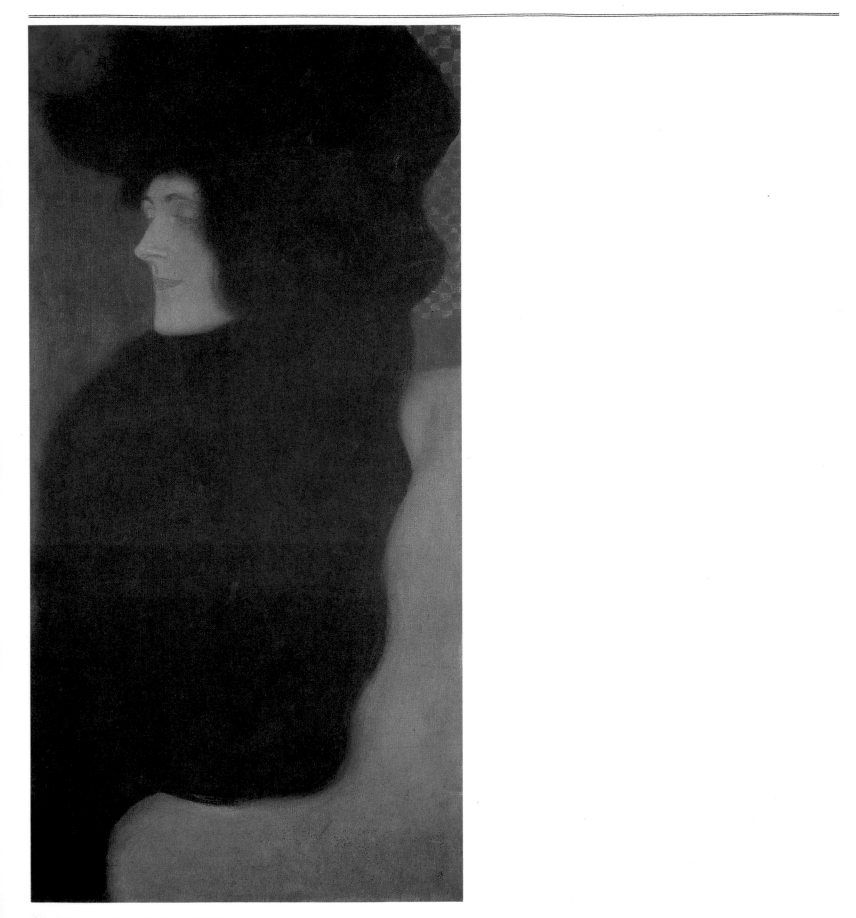

Plate 8 **Gustav Klimt** Pale Face. 1907-8.

Plate 9 **Gustav Klimt** Pine Forest II. 1901.

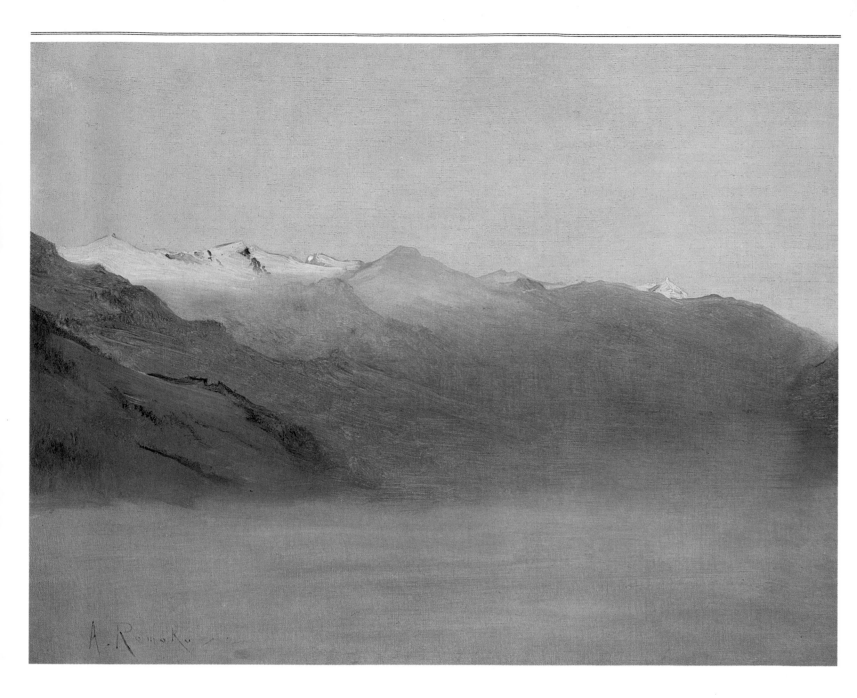

Plate 10 **Anton Romako** Gastein Valley in the Fog. 1877.

Plate 11 **Alfred Kubin** Plateau Landscape. Ca. 1907.

Plate 12 **Gustav Klimt** Castle Pond in Kammer on the Attersee. Before 1910.

Plate 13 **Richard Gerstl** Small Garden Painting.

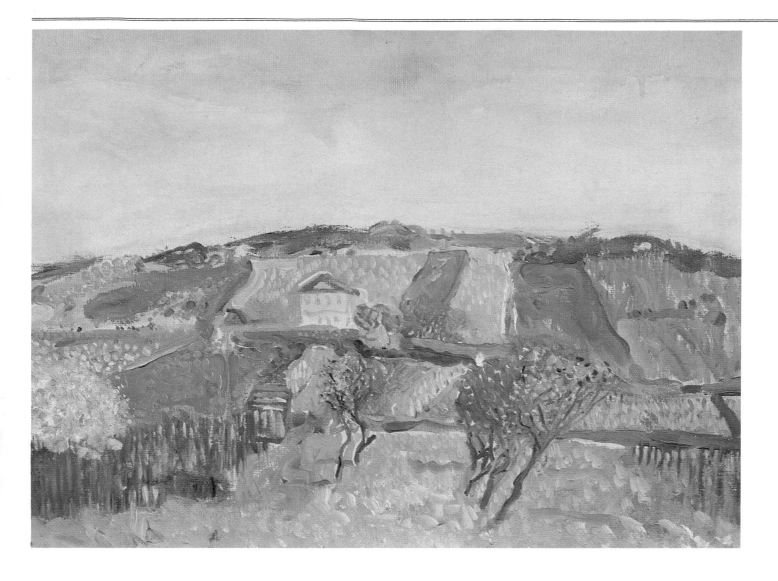

Plate 14 **Richard Gerstl** Grinzing.

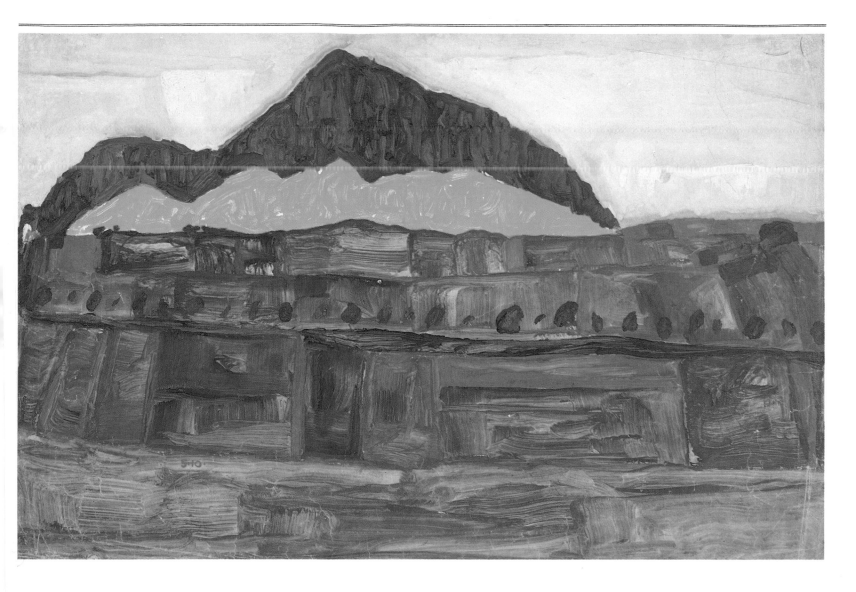

Plate 15 **Egon Schiele** Mountain Landscape. 1910.

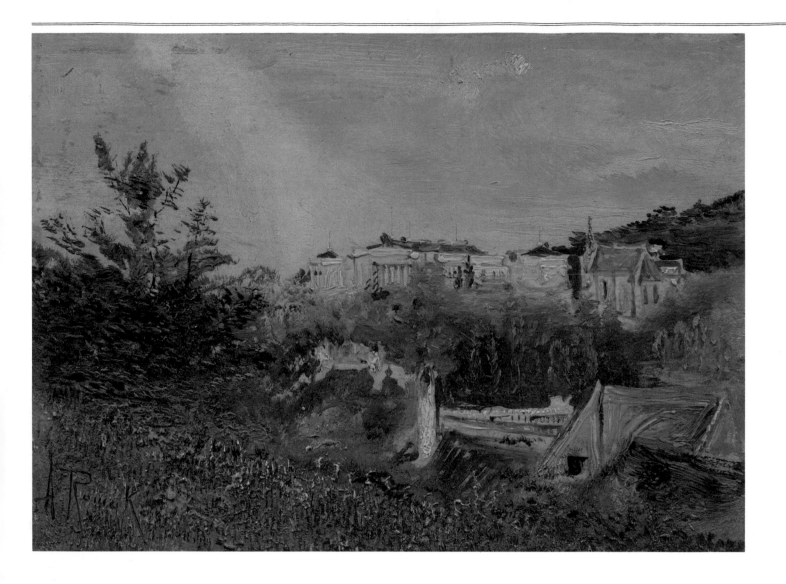

Plate 16 **Anton Romako** The Weilburg with Cholera Chapel Near Baden. 1885.

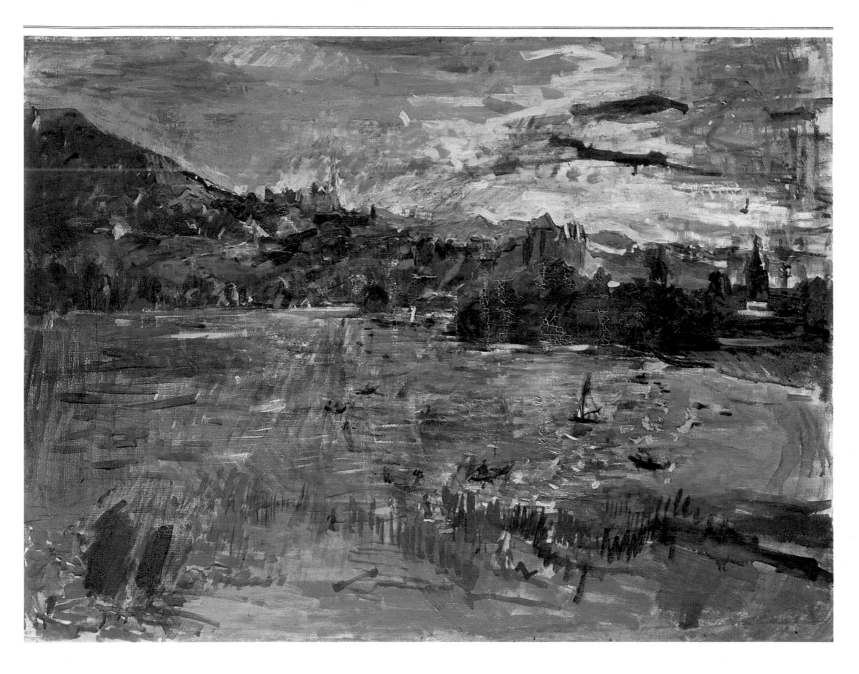

Plate 17 **Oskar Kokoschka** Lac d'Annecy II. Ca. 1930.

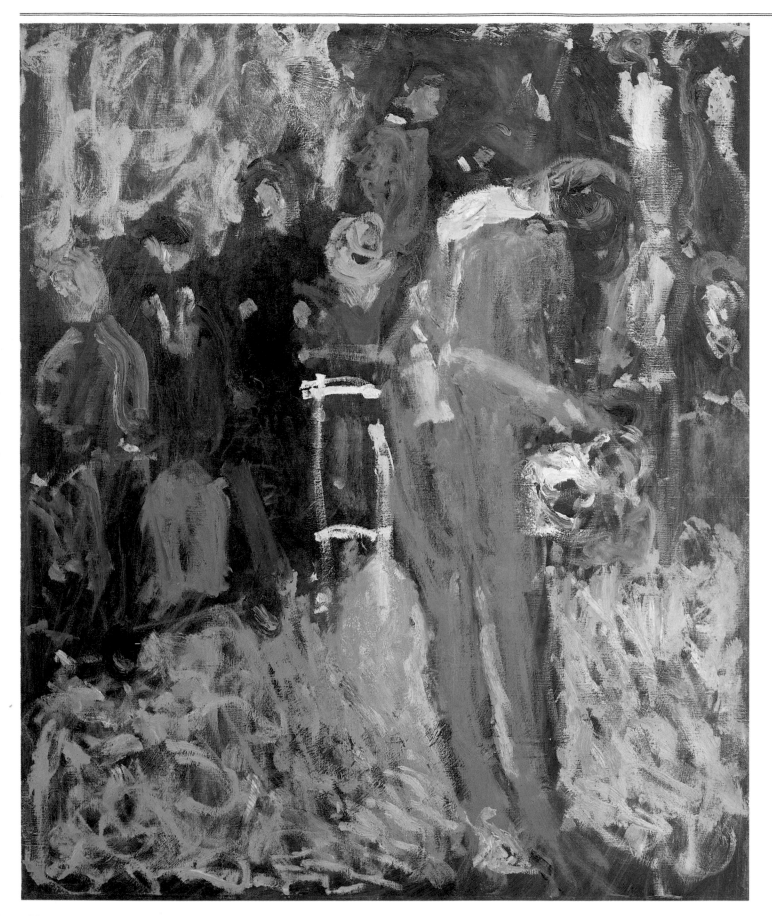

Plate 18 **Richard Gerstl** Nude in Garden. Ca. 1908.

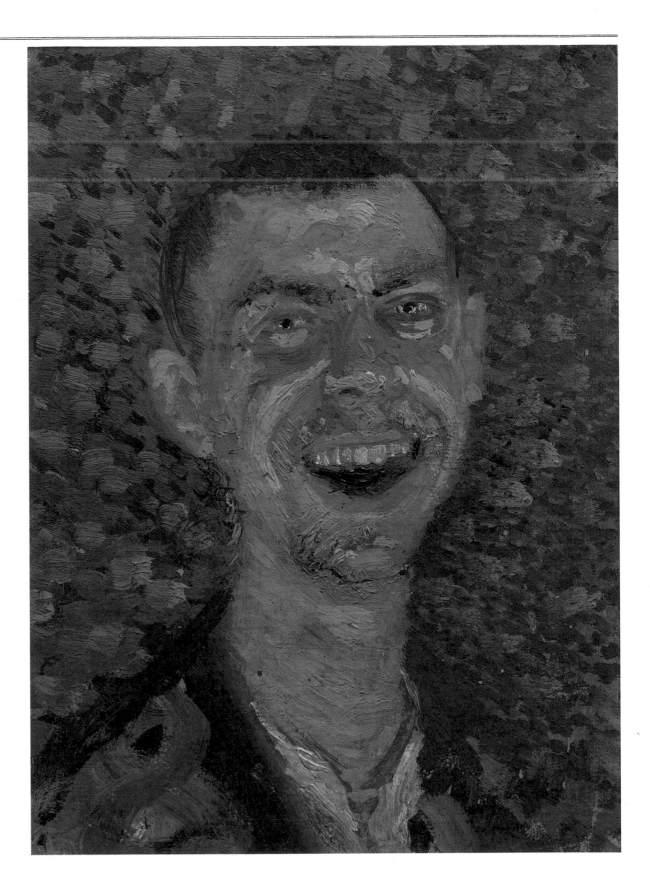

Plate 19 **Richard Gerstl** Self-Portrait, Laughing.

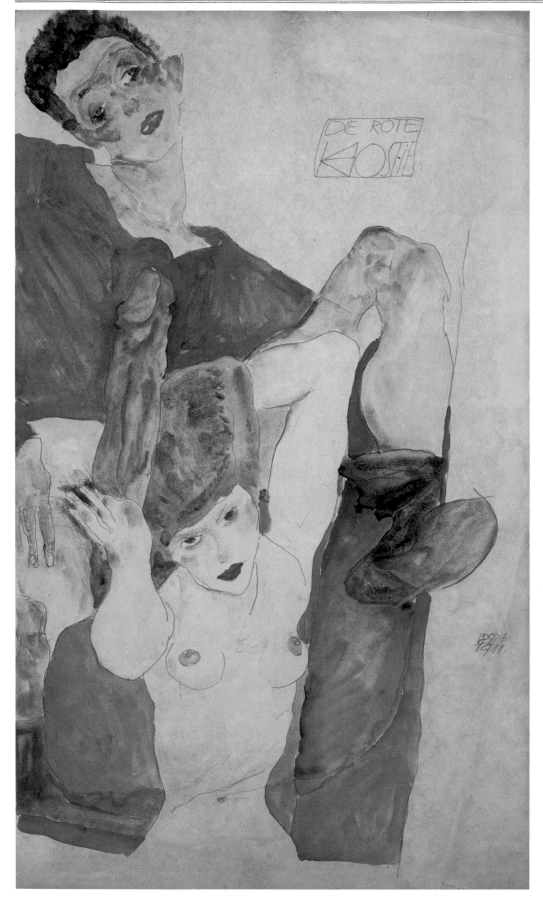

Plate 20 **Egon Schiele** The Red Host. 1911.

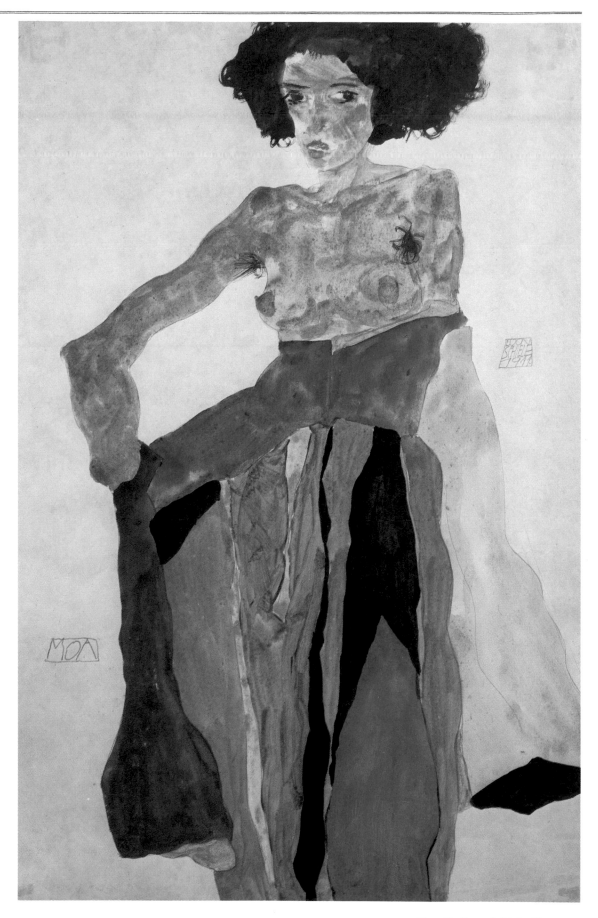

Plate 21 **Egon Schiele** Moa. 1911.

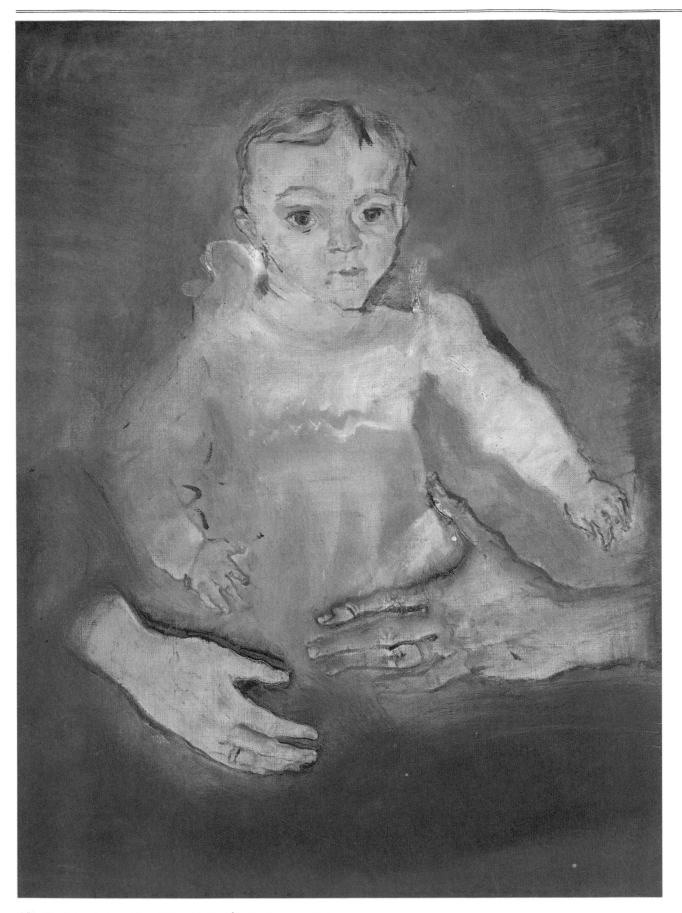

Plate 22 **Oskar Kokoschka** Child with Hands of its Parents. 1909.

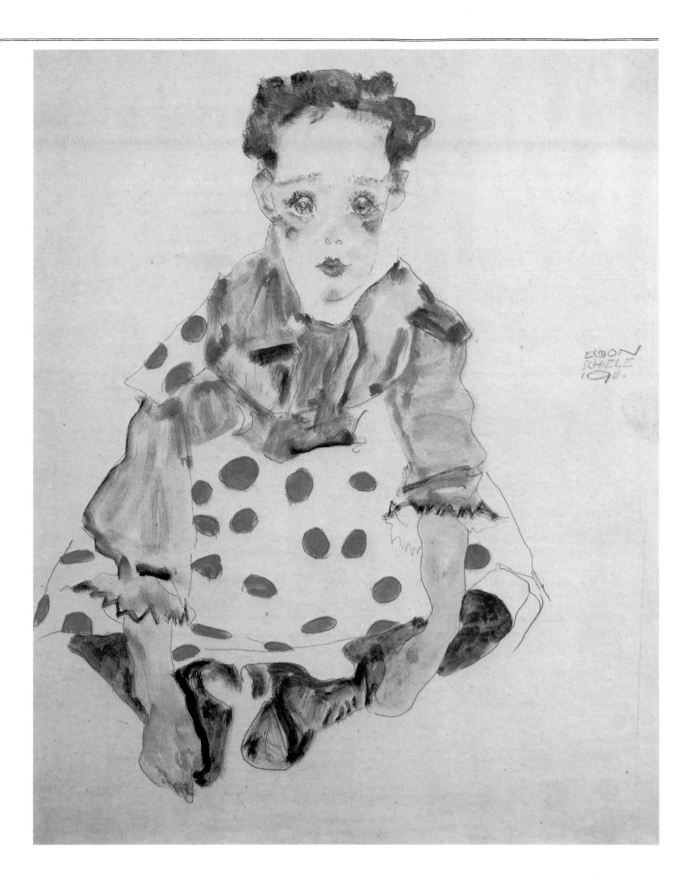

Plate 23 **Egon Schiele** Girl in Polka Dot Dress. 1911.

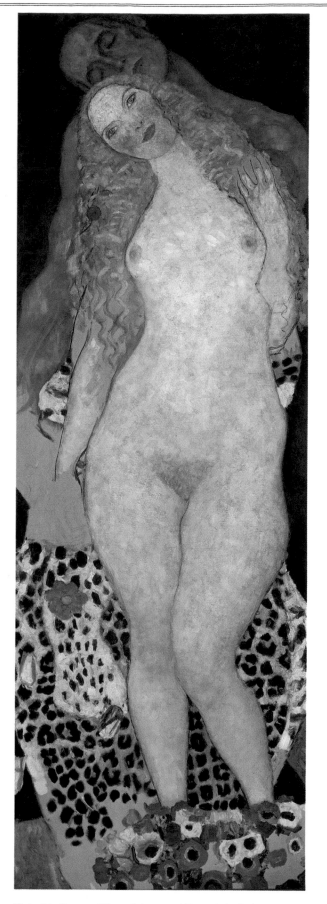

Plate 24 **Gustav Klimt** Adam and Eve. 1917-18.

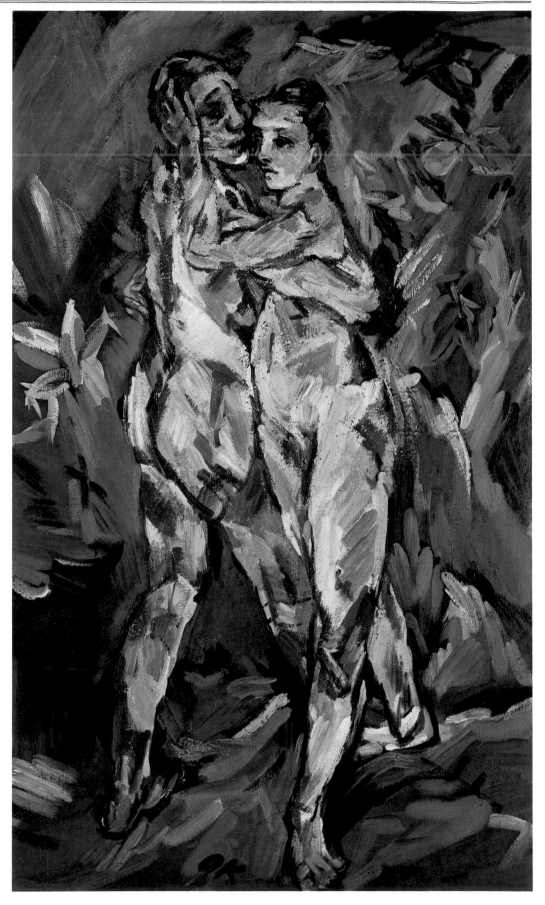

Plate 25 **Oskar Kokoschka** Two Nudes (Dancing Couple). Ca. 1913.

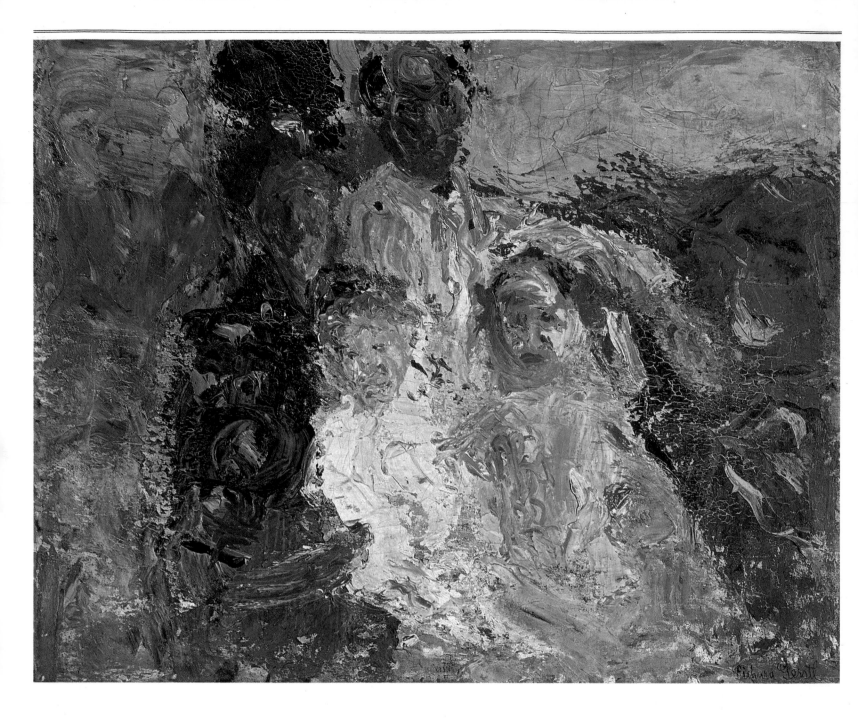

Plate 26 **Richard Gerstl** Portrait of the Arnold Schönberg Family. Ca. 1908.

Plate 27 **Egon Schiele** The Family (Squatting Couple). 1917-18.

Plate 28 **Ludwig Heinrich Jungnickel** Three Tigers.

Plate 29 **Alfred Kubin** Dispatching a Treasure. Ca. 1908.

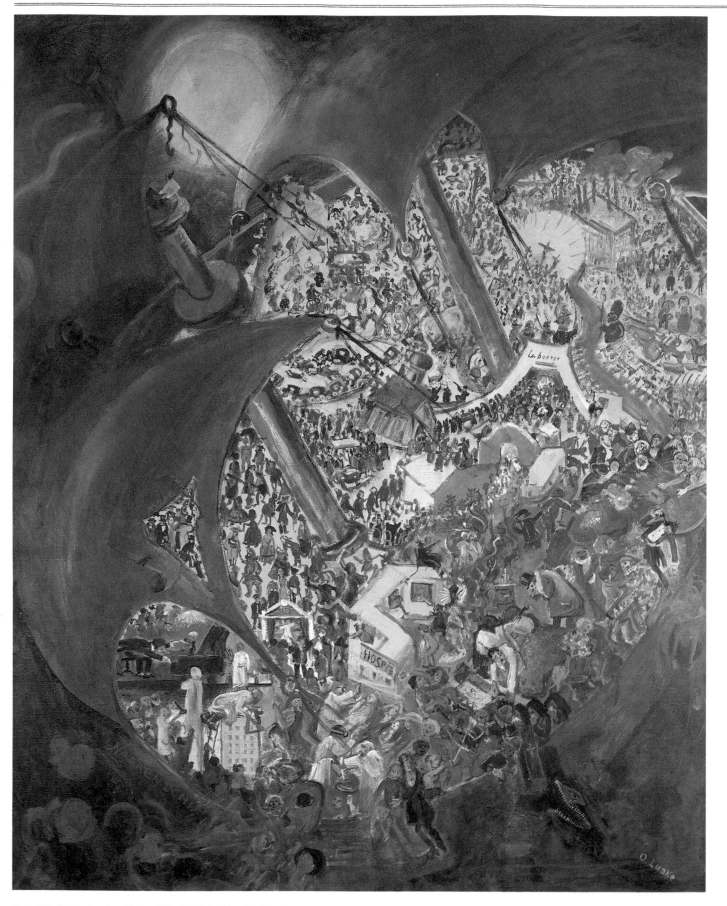

Plate 30 **Oskar Laske** Ship of Fools (Third Version). 1949.

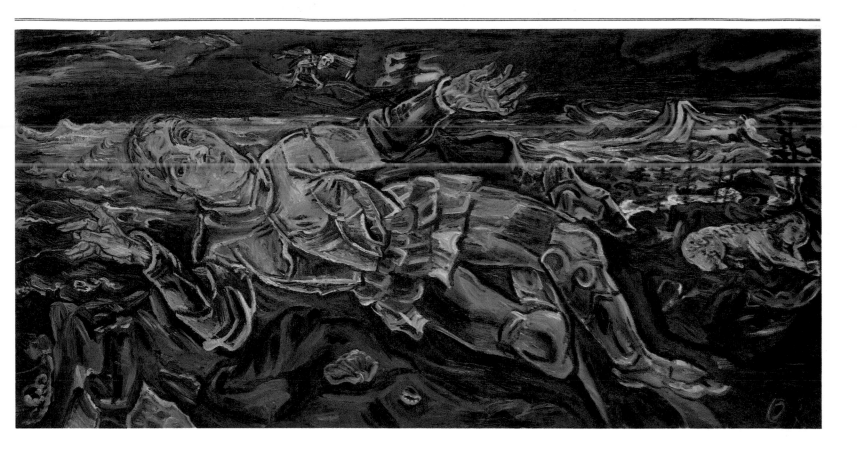

Plate 31 **Oskar Kokoschka** Knight Errant. 1915.

LIST OF PUBLICATIONS

Issued by Dr. Otto Kallir under various imprints.

1919

Johannes Itten/10 Originallithographien Portfolio of 10 lithographs and 3 lithographic text pages in Itten's calligraphy. Edition of 200 copies, signed in the colophon. Deluxe edition of 25 numbered copies, the colophon and each lithograph signed by Itten. Folio. Vienna: Richard Lanyi (*Erster Daidalos Druck*, taken over by Verlag Neuer Graphik).

Faust Impressionen Portfolio of 9 etchings and cover lithograph by Oskar Laske. Edition of 60 copies, each etching numbered, titled and signed by Laske. Folio. Vienna: Verlag Neuer Graphik.

Singende Blinde, Verträumte, Dostojewskij Illustration 3 lithographs by Georg Ehrlich, published individually. Each impression signed and inscribed by Ehrlich. Normal edition. Deluxe edition, numbered I–X, on Bütten paper. Vienna: Verlag Neuer Graphik.*

1920

Kreuzannagelung, Sommerlicher Garten 2 lithographs by Felix Albrecht Harta, published individually, each signed by Harta. Edition of 40 impressions on rag paper, 10 on Bütten paper. Vienna: Verlag Neuer Graphik.*

Würthle & Sohn Nachfg., Abteilung Verlag Neuer Graphik, Wien Illustrated catalogue describing the aims of the "Publishers of New Graphics," founded in 1919, giving information on the first publications and announcing projects for 1920. Trade edition. Deluxe edition of 100 numbered copies, each containing a signed etching by L. H. Jungnickel. 8vo. Vienna: Verlag Neuer Graphik.

Wassermann-Mappe 12 graphic works by members of the artists' association *Der Wassermann*: R. C. Andersen, K. Caspar, A. Faistauer, J. Fischer, F. A. Harta, L. H. Jungnickel, A. Kubin (Raabe 128), G. Merkel, A. Peschka, E. Schlangenhauser, J. W. Schülein, J. Zimpel. Edition of 170 copies, each print signed by the respective artist; 150 copies on rag paper, in half-cloth portfolio; 20 copies on "Kupferdruck" paper, in half-parchment portfolio. Folio. Vienna: Verlag Neuer Graphik.*

Alfred Kubin: Drei Lithographien 3 lithographs, *Märchenprinzessin, Pferdeschwemme, Der steinerne Fischer*, in paper cover with text lithographed in Kubin's facsimile handwriting. Edition of 75 copies, numbered in the colophon, each lithograph signed by Kubin. Folio. Vienna: Verlag Neuer Graphik (Raabe 127 a, b, c).

L'Aérostat *Six poëmes à l'honneur des premiers voyageurs aériens publiés . . . 1784*. Calligraphy and illustrations: lithographs by Julius Zimpel, the illustrations hand-colored by him. Edition of 25 numbered copies, signed by Zimpel in the colophon, some bound in leather and in box, some in half-leather and in slipcase. 8vo. Vienna: Verlag Neuer Graphik.

1921

Der fahrend Schüler im Paradeis *Ein kurzweilig Fastnachtsspiel von Hans Sachs aus Nürnberg*. Calligraphy and illustrations: lithographs by Julius Zimpel, the illustrations hand-colored by him. Edition of 25 numbered copies, signed by Zimpel in the colophon, bound in half-leather and in slipcase. 4to. Vienna: Verlag Neuer Graphik der Rikola AG.

Poésies choisies dans "Serres Chaudes" By Maurice Maeterlinck. Calligraphy: lithographs by Julius Zimpel. Illustrations: lithographs by Charles Doudelet. Edition of 125 copies; nos. I–XV signed by Maeterlinck and Doudelet in the colophon and illustrations hand-colored by Doudelet, bound in parchment and in slipcase. 4to. Vienna: Verlag Neuer Graphik/Rikola Verlag.

Das Buch Jona Calligraphy: lithographs by Julius Zimpel. Illustrations: lithographs by Uriel Birnbaum. Edition of 300 numbered copies, signed by Birnbaum in the colophon, bound in half-parchment. Folio. (Vienna): Verlag Neuer Graphik der Rikola Verlag AG.

Internationale Schwarz-Weiss Ausstellung Exhibition catalogue, Künstlerhaus, Salzburg (August 19–October 3), with original graphic works by A. Faistauer, R. Grossmann, F. A. Harta, L. H. Jungnickel, A. Kubin (Raabe 140), K. Rössing, E. Scharff, R. Seewald, J. Zimpel. Trade edition of 600 copies. Deluxe edition of 100 numbered copies, graphic works signed by the respective artists, and including an etching by Egon Schiele (Kallir 5), cloth binding. 8vo. Vienna: Verlag Neuer Graphik der Rikola AG.

Anton Hanak By Max Eisler. Trade edition. 8vo. Deluxe edition of 100 numbered copies with reproduction of a drawing signed by Hanak, nos. 1–10 containing in addition an original drawing, bound in half-leather. 4to. Vienna-Berlin-Munich-Leipzig: Verlag Neuer Graphik/Rikola Verlag.

Oskar Laske By E. Tietze-Conrat. With oeuvre catalogue of graphic works, 1904–1921. Trade edition. Deluxe edition of 100 numbered copies, including an etching, signed and numbered by Laske. 4to. Vienna-Berlin-Leipzig-Munich: Rikola Verlag.

1922

Frühstück am Strande, Das Warenhaus 2 facsimile reproductions of watercolors by Alfred Kubin, published individually (Raabe 170, 176). Unsigned prints and edition of 250 prints, signed by Kubin. Vienna: Rikola Verlag.

Das Graphische Werk von Egon Schiele Portfolio of 6 etchings and 2 lithographs by Schiele (Kallir 3, 4, 5, 6, 7, 8, 16, 17). Introduction by Arthur Roessler. Edition of 80 copies, numbered in the colophon. Folio. Vienna-Berlin-Leipzig-Munich: Rikola Verlag/Verlag Neuer Graphik. Additional impressions of these works were sold individually.

Vom Glück der Sehnsucht *Ein indisches Märchen*. By Rathi Dhumaketu (German translation by Ernst Roenau). With 5 lithographs by Otei. Edition of 250 copies. 4to. Vienna-Berlin-Leipzig-Munich: Rikola Verlag.

Phaëton By Hans Reisiger. With a woodcut by Ludwig von Hofmann. Edition of 220 numbered copies, signed by Reisiger in the colophon, the woodcut signed by Hofmann; nos. I–XX on heavy Bütten paper and the woodcut hand-printed, bound in half-leather. Folio. Vienna-Berlin-Leipzig-Munich: Rikola Verlag.

Carl Leopold Müller *Ein Künstlerleben in Briefen, Bildern und Dokumenten*. Edited by A. F. Seligmann. Vienna-Berlin-Leipzig-Munich: Rikola Verlag.*

Die Blumen der kleinen Ida By Hans Christian Andersen. With 5 lithographs by Rudolf Grossmann. Edition of 500 numbered copies; nos. 1–100 signed by Grossmann in the colophon; nos. I–XX include an original drawing and each lithograph hand-colored and signed by Grossmann, bound in half-leather and in box. 4to. Vienna: Verlag Neuer Graphik des Rikola Verlages.

Italienisches Skizzenbuch 40 lithographs by Ludwig Heinrich Jungnickel and 3 lithographed text pages in Jungnickel's facsimile handwriting. Trade edition. Edition numbered 1–150 on "Japan document" paper, signed in the colophon. 4vo. Deluxe edition, numbered I–XXV, on heavy Bütten paper, each lithograph signed, in box. Folio. Vienna-Berlin-Leipzig-Munich: Rikola Verlag AG/Verlag Neuer Graphik.

Auf der Flucht nach Ägypten Portfolio of 8 etchings by Oskar Laske and text sheet in Laske's facsimile handwriting. Edition of 100 numbered copies, all etchings numbered and signed, nos. I–XV including a hand-colored etching. Folio. Vienna-Berlin-Leipzig-Munich: Rikola Verlag/Verlag Neuer Graphik.

Evangelienbilder 34 lithographs by Ernst Wagner and 3 lithographed text pages in Wagner's facsimile handwriting. Edition of 200 numbered copies, signed in the colophon, some bound, some in portfolio and each picture initialed. Folio. Vienna-Berlin-Leipzig-Munich: Rikola Verlag/Verlag Neuer Graphik.

Ferien *Eine Erzählung*. By E. A. Rheinhardt. With 6 woodcuts by R. Pajer-Gartegen. Trade edition. Deluxe edition of 115 numbered copies, signed by Rheinhardt and Pajer-Gartegen in the colophon; in nos. I–XV each woodcut signed and a separate set of hand-printed impressions included, bound in

linen. 8vo. Vienna-Berlin-Leipzig-Munich: Rikola Verlag/Verlag Neuer Graphik.

Ain Lobspruch der Haubtstat Wien in Oesterreich von Hans Sachs aus Nürnberg Text calligraphy and illustrations: lithographs by Julius Zimpel. Edition of 125 numbered copies, signed in the colophon; in nos. I–XXV each lithograph hand-colored by Zimpel, in portfolio designed by him. Folio. Vienna; Verlag Neuer Graphik der Rikola AG.

Die Teufelstriller Sonate By Guiseppe Tartini. Portfolio of 11 pages of score and 2 text pages, all with illustrations designed and etched on stone by Julius Zimpel. Trade edition of 500 numbered copies. Deluxe edition of 50 numbered copies, each page signed by Zimpel. Folio. Vienna: Verlag Neuer Graphik des Rikola Verlages.

Die Gedichte um Netra By Rudolf Kindermann. Text calligraphy and illustrations: lithographs by Rudolf Zimpel. Edition of 100 numbered copies, signed by Kindermann in the colophon, bound in half-parchment. 8vo. Hannover: Galerie v. Garvens and Vienna: Verlag Neuer Graphik der Rikola Verlag AG.

Gustav Klimt/Zehn Handzeichnungen Portfolio of 10 reproductions of drawings by Klimt. Introduction by Gustav Glück. 4to. Vienna-Berlin-Leipzig-Munich: Rikola Verlag.

Georg Merkel By Hans Tietze. Trade edition, 8vo. Deluxe edition of 100 numbered copies, each including a signed lithograph by Merkel. 4to. Vienna-Berlin-Leipzig-Munich: Rikola Verlag.

Bekenntnisse des Hochstaplers Felix Krull *Buch der Kindheit.* By Thomas Mann. With 6 color lithographs by Oskar Laske. Edition of 500 numbered copies; nos. 1–100 signed by Mann in the colophon, lithographs signed by Laske, in slipcase. 4to. Vienna-Leipzig-Munich: Rikola Verlag.

Klarer Klang By Hugo Salus. Trade edition. Deluxe edition of 100 numbered copies, signed by Salus in the colophon, bound in half-parchment. 4to. Vienna: Rikola Verlag.

1923

Blick auf eine Stadt, Pietà, Selbstmörderfriedhof, Strassenszene (Der alte Gaul) Lithographs by Alfred Kubin, published individually (Raabe 198, 209, 211, 214). Editions of 125 impressions each: 100 on rag paper, 25 on "Japan document" paper. Vienna: Neue Galerie.

1924

Der Bibliophile (Das grosse Buch) Design for a poster. Lithograph by Alfred Kubin, published individually (Raabe 239). Edition of 50 signed impressions. Vienna: Neue Galerie.

Der gestiefelte Kater Lithograph by Alfred Kubin, published individually (Raabe 244). Edition of 33

signed impressions for the *Gesellschaft der 33.* Vienna: Neue Galerie. *

Michel Blümelhuber *Der Stahlschnittmeister in Steyr.* By Eduard Kapralik. Trade edition. Deluxe edition of 100 numbered copies, signed by Blümelhuber in the colophon. 4to. Vienna-Leipzig-Munich: Rikola Verlag.

Frank Brangwyn: Der Radierer *Eine Würdigung.* By A. S. Levetus. Trade edition. Deluxe editions: nos. 1–150 and nos. I–LX, both including original etchings by Brangwyn. 4to. Vienna-Leipzig-Munich: Rikola Verlag.

Paul Signac By Claude Roger-Marx. Exhibition catalogue, Neue Galerie (May). Trade edition, 8vo. Deluxe edition of 100 numbered copies, including a signed lithograph *Harbor Scene* by Signac. 4to. Vienna: Neue Galerie.

Ein altes deutsches Weihnachtsspiel By Max Mell. Edition of 50 numbered copies, signed by Mell in the colophon, bound in half-parchment and in slipcase. 4to. Vienna: Johannes-Presse (*Erster Druck*).

Ebbi *(A comedy).* Text and 6 etchings by Max Beckmann. Edition of 33 numbered copies for the *Gesellschaft der 33,* each etching and the colophon signed by Beckmann, bound in half-leather and in slipcase. 4to. Vienna: Johannes-Presse (*Zweiter Druck*) (Gallwitz 274–276).

Friedrich Inhauser/Sechs Lithographien 6 signed and numbered lithographs and one drawing. Edition of 12 copies, in half-leather portfolio. Vienna: Neue Galerie. *

Otto Silbert/Lithographien 6 signed lithographs and one drawing. Edition of 12 copies, in half-linen portfolio. Vienna: Neue Galerie. *

1925

Gedichte By Hugo von Hofmannsthal. With a signed lithograph by Hugo Steiner-Prag. Edition of 33 numbered copies for the Bibliographisches Institut, Leipzig, signed by Hofmannsthal and Steiner-Prag in the colophon. 8vo. Vienna: Johannes-Presse (*Dritter Druck*).

Der Guckkasten 8 short stories and 8 lithographs by Alfred Kubin. Trade edition of 1,000 copies with linecuts of the lithographs, 8vo. Deluxe edition of 33 numbered copies for the *Gesellschaft der 33,* each lithograph signed by Kubin, some bound in half-leather, some in leather and in slipcase. Folio. Vienna: Johannes-Presse (deluxe edition only: *Vierter Druck der Johannes-Presse*) (Raabe 292).

Kundmachung Lithograph by Alfred Kubin, published individually. Edition of 90 impressions: 70 printed in brown, 20 of them signed, as a birth announcement; 20 signed impressions offered for sale. Vienna; Neue Galerie (Raabe 297).

Vierzig Holzschnitte Collection of 40 woodcuts by

Otto Rudolf Schatz. Edition of 10 numbered sets, each impression hand-printed and signed by Schatz, in box. Vienna: Johannes-Presse (*Fünfter Druck*). *

1926

Szenischer Prolog zur Neueröffnung des Josefstädter Theaters By Hugo von Hofmannsthal. Edition of 350 numbered copies, presented by author and publisher to the participants of the German Librarians' Meeting and the Jubilee celebration of the National Library in Vienna. 8vo. Vienna: Johannes-Presse (*Sechster Druck*).

Geh, mach die Türe zu, es zieht Comedy by Bohuslav Kokoschka. With 2 etchings by Oskar Kokoschka (Wingler/Welz 167, 168). Edition of 33 numbered copies, each etching signed by Oskar Kokoschka, nos. I–IV containing in addition a separate set of signed trial proofs, in box. 4to. Vienna: Johannes-Presse (*Siebenter Druck*).

1927

In Memoriam Julius Zimpel/Tränen des Vaterlands By Andreas Gryphius. Text calligraphy and illustrations: woodcuts by Julius Zimpel. Edition of 10 numbered copies, bound in leather and in slipcase. 8vo. Vienna: Johannes-Presse (*Achter Druck*).

Magie By Max Roden. With 5 lithographs and cover illustration by Alfred Kubin. Trade edition of 500 copies. Deluxe edition of 10 numbered copies, signed by Roden and Kubin in the colophon, including a separate set of the lithographs, each hand-colored and signed by Kubin, bound in leather and in box. 8vo. Vienna: Johannes-Presse (deluxe edition only: *Neunter Druck der Johannes-Presse*) (Raabe 386).

1930

Rede des Schaffenden By Max Roden. Trade edition of 300 copies. Deluxe edition of 10 numbered copies, signed by Roden in the colophon, bound in leather and in slipcase. 8vo. Vienna: Johannes-Presse (deluxe edition only: *Zehnter Druck der Johannes-Presse*).

Worte ins Ewige By Max Roden. Trade edition of 300 copies. Deluxe edition of 10 numbered copies, signed by Roden in the colophon. 8vo. Vienna: Johannes-Presse (deluxe edition only: *Elfter Druck der Johannes-Presse*).

Das Graphische Werk von Gerhart Frankl Two portfolios of approximately 45 etchings by Frankl, each impression numbered and signed. Very small edition. Folio. Vienna: Johannes-Presse (*Zwölfter Druck*). *

Gerhart Frankl By Hans Tietze. With oeuvre catalogue of etchings, 1927-1928. Trade edition. Deluxe edition of 15 copies, each including separately a signed etching, bound in half-leather and in box. 8vo. Vienna: Neue Galerie.

1931

Alfred Kubin Exhibition catalogue, Neue Galerie (April—May). With foreword, 10 lithographs and cover design by Kubin. Trade edition of 235 copies. Deluxe edition of 15 numbered copies, lithographs and colophon signed by Kubin, bound in linen. Vienna: Neue Galerie (Raabe 429).

Eva (*Adam und Eva*) Lithograph by Alfred Kubin, published individually. Regular edition: enclosure in *Österreichische Kunst*, 1931/5. Edition of 30 signed impressions on **Bütten** paper. Vienna: Neue Galerie (Raabe 425).

1932

Ali, der Schimmelhengst—Schicksale eines Tartarenpferdes By Alfred Kubin. Portfolio of lithographs: title design, 3 text pages in Kubin's facsimile handwriting and 12 pictures. Edition of 83 numbered copies, each page signed by Kubin; nos. 1–80 printed on rag paper, in half-parchment portfolio handmade by Gustav Zimpel; nos. I–III printed on **Bütten** paper and containing in addition 2 drawings (sketches for this work), in box handmade by Gustav Zimpel. Folio. Vienna: Johannes-Presse (*Dreizehnter Druck*) (Raabe 451).

1933

Sterners Weg zu Angelina By Max Roden. 8vo. Vienna: Johannes-Presse.

1934

Sang der Zeit By Max Roden. 8vo. Vienna: Johannes-Presse.

Zehn Jahre Neue Galerie Exhibition catalogue (March–April). With lithograph *Dorfhexe* by Alfred Kubin. Edition of 400 copies. The lithograph was also published individually: edition of 80 signed impressions on **Bütten** paper. 8vo. Vienna: Neue Galerie (Raabe 504).

1935

Das ist die Stimme By Max Roden. 8vo. Vienna: Johannes-Presse.

Vom Urgrund her By Max Roden. 8vo. Vienna: Johannes-Presse.

Licht und Landschaft By Richard Götz. Trade edition. Deluxe edition of 30 numbered copies, signed by Götz in the colophon. 8vo. Vienna: Johannes-Presse.

Patmos *Zwölf Lyriker*. Anthology of lyrical poems by 12 Austrian authors, among them, Felix Braun, Hermann Broch, Robert Musil, edited by Ernst Schönwiese. Trade edition. Deluxe edition of 50 numbered copies, signed by all the authors, bound in half-leather and in slipcase. 8vo. Vienna: Johannes-Presse.

1936

Adolf Loos Privat By Claire Loos. 8vo. Vienna: Johannes-Presse.

Dramatische Entwürfe aus dem Nachlass By Hugo von Hofmannsthal. *Anmerkung* by Heinrich Zimmer. Edition of 520 copies; nos. 1–500 on rag paper, numbered by machine, bound in silk; nos. I–XX on "Japan document" paper, hand-numbered, bound in half-leather. 8vo. Vienna: Johannes-Presse.

Vorspiel auf dem Theater zu König David By Richard Beer-Hofmann. Trade edition. Deluxe edition of 25 numbered copies, signed by Beer-Hofmann in the colophon, bound in silk. 8vo. Vienna: Johannes-Presse.

Du allem ausgesetztes Herz By Fritz Schey. Trade edition. Deluxe edition of 100 numbered copies, signed by Schey in the colophon, bound in half-leather and in slipcase. 8vo. Vienna: Johannes-Presse.

1937

Rainer Maria Rilke By Friedrich Gundolf. Trade edition. Deluxe edition of 20 numbered copies, bound in half-parchment and in slipcase. 8vo. Vienna: Johannes-Presse.

Immer und immer By Max Roden. With 7 lithographs by Alfred Kubin. Edition of 43 numbered copies, signed by Roden and Kubin in the colophon; nos. I–III containing a separate set of signed trial proofs of the lithographs on **Bütten** paper, bound in half-leather, in box. 4to. Vienna: Johannes-Presse (Raabe 558).

Tschandala By August Strindberg (German translation by Emil Schering). With 33 lithographs by Alfred Kubin. Edition of 90 numbered copies, the 10 full-page lithographs and the colophon signed by Kubin; nos. 1–80 bound in boards and in slipcase; nos. I–X on **Bütten** paper, bound in leather, including 2 separate sets of signed trial proofs of the lithographs, printed in blue and in reddish-brown respectively, contained in box, together with book, in half-leather slipcase. 4to. Vienna: Johannes-Presse (*Vierzehnter Druck*) (Raabe 559).

1938

Macht man denn aus Kalk die Terzen . . . ? *Schüttelreime*. By Franz Mittler. 8vo. Vienna: Neue Galerie.

1944

Aus dem Fragment Paula: Herbstmorgen in Österreich By Richard Beer-Hofmann. Trade edition of 250 copies. Deluxe edition of 75 numbered copies, signed by Beer-Hofmann in the colophon. 8vo. New York: Johannespresse.

Ewald Tragy By Rainer Maria Rilke. Edited by Richard von Mises. Trade edition. Deluxe edition of 100 numbered copies, bound in linen. 8vo. New York: Johannespresse.

1945

Schlaflied für Mirjam By Richard Beer-Hofmann. Written by Beer-Hofmann on lithographic transfer paper and printed for his friends. Edition of 25 numbered copies, signed by Beer-Hofmann in the colophon. Folio.

Briefe an Baronesse von Oe. By Rainer Maria Rilke. Edited by Richard von Mises. Trade edition. Deluxe edition of 100 numbered copies, bound in linen. 8vo. New York: Johannespresse.

1946

Briefe, Verse und Prosa aus dem Jahre 1896 By Rainer Maria Rilke. Edited by Richard von Mises. Trade edition. Deluxe edition of 100 numbered copies, bound in linen. 8vo. New York: Johannespresse.

Jacob's Dream By Richard Beer-Hofmann (English translation by Ida Bension Wynn). Introduction by Thornton Wilder. Biographical Essay by Solomon Liptzin. 8vo. New York: Johannespresse. (A separate edition: Philadelphia: The Jewish Publication Society.)

1949

Paula *Ein Fragment*. By Richard Beer-Hofmann. *Nachwort des Herausgebers* by Otto Kallir. Trade edition. Deluxe edition of 360 copies for the members of the Richard Beer-Hofmann Society. 8vo. New York: Johannespresse.

1951

Spiegelungen By Max Roden. With an illustration by Alfred Kubin. Edition of 200 copies. 8vo. Vienna: Johannes-Presse.

1961

Amerika ist um mich her By Max Roden. 8vo. Vienna: Neue Galerie.

Gestalt im Wandel By Max Roden. 8vo. Vienna: Neue Galerie.

1965

Mein Weg mit Egon Schiele By Heinrich Benesch. Edited by Eva Benesch. Edition of 500 copies. 8vo. New York: Johannespresse.

1967

A Sketchbook by Egon Schiele Facsimile edition, and separate volume of commentary in English and German by Otto Kallir. Trade edition of 500 copies, the 2 volumes in cloth slipcase. Deluxe edition of 50 numbered copies, including handprints from 2 rubber stencils by Schiele (Kallir 11, 12), the 2 volumes in half-leather box. 8vo. New York: Johannes Press.

1968

Alfred Kubin's Autobiography Reprinted from *The Other Side* by Alfred Kubin (English translation by Denver Lindley; New York: Crown Publishers, 1967). Edition of 1,000 copies. 8vo. New York: The Galerie St. Etienne.

*Information partly gathered from secondary sources.

LIST OF EXHIBITIONS

Organized by Otto Kallir and his associates in Austria, France and the United States. Dates refer to the opening of each exhibition. Authors of catalogue texts are listed in parentheses at the end of each entry.

Exhibition organized by Dr. Otto Kallir at the Künstlerhaus, Salzburg.

International Black and White Exhibition August 19—October 3, 1921. Organized by the artists' association, *Der Wassermann*, in Salzburg, in association with Würthle & Sohn, Vienna.

Exhibitions organized by Dr. Otto Kallir at the Neue Galerie, Grünangergasse 1, Vienna.

1 **Egon Schiele** November 20, 1923. Paintings, watercolors and drawings (Dr. Kurt Rathe).

2 **Georg von Pojedaieff** *Designs for the "Blauer Vogel"* January 1, 1924.

3 **Drawings by 19th Century German Masters** January 20, 1924. C. D. Friedrich, K. Spitzweg, H. Thoma and others.

4 **Group Exhibition** February 1, 1924. A. Faistauer, L. H. Jungnickel, M. Liebermann and others.

5 **Russian Exhibition** February 15, 1924. A. Archipenko, M. Chagall, W. Kandinsky and E. Lissitzky. In association with the Gesellschaft zur Förderung moderner Kunst in Vienna.

6 **Edvard Munch** March 8, 1924. Paintings and graphics (Curt Glaser).

7 **Alfred Kubin** April, 1924. Drawings and watercolors. Organized by Fritz Gurlitt, Berlin, and held at the Neue Galerie (Alfred Kubin).

8 **Paul Signac** May 17, 1924. Paintings, watercolors and drawings (Claude Roger-Marx).

9 **Oskar Kokoschka** *Part I*. June 24, 1924. Watercolors, drawings and graphics.

10 **Otto Rudolf Schatz and Mario Petrucci** September 13, 1924. Watercolors, drawings and graphics by Schatz; sculptures by Petrucci.

11 **Oskar Kokoschka** *Part II*. October 13, 1924. Paintings from 1907 to 1915.

12 **Max Slevogt** October 31, 1924. Drawings and graphics.

13 **Christmas Exhibition** December 1, 1924. Oskar Laske, Marianne Mendl, artists of the Wiener Werkstätte and others.

14 **Marcel Vertes** January 3, 1925.

15 **Alfred Kubin** January 20, 1925. Drawings and watercolors.

16 **Hugo Steiner-Prag** March 6, 1925. Book illustrations, drawings, graphics and watercolors (Franz Servaes).

17 **Gagnhild d'Ailly** March 21, 1925. Batiks.

18 **Max Beckmann** March 28, 1925. Drawings and graphics.

19 **American Exhibition** April 24, 1925. Paintings, sculpture and graphics by G. Biddle, M. Hartley, J. Pascin, M. Sterne and others.

20 **Group Exhibition** June 13, 1925. A. Faistauer, F. Probst, O. R. Schatz, M. Seeland and crafts by A. Lesznai.

21 **Julius Zimpel** October 6, 1925.

22 **Ferdinand Georg Waldmüller and Martin Johann Schmidt (Kremserschmidt)** November 21, 1925. Paintings by Waldmüller and drawings by Schmidt (Bruno Grimschitz).

23 **First Sales Exhibition** January 19, 1926.

24 **Caspar David Friedrich** April 10, 1926. Drawings.

25 **Gustav Klimt** May 20, 1926.

26 **Arthur Polzer-Hoditz** June 26, 1926.

27 **The Unknown 19th Century in Works of Austrian Art** *Part I*. October 7, 1926. Drawings and watercolors.

28 **Lovis Corinth** *Memorial Exhibition, Part I*. November 7, 1926. Drawings, graphics and watercolors. Held at the Hagenbund (Alfred Stix).

29 **Anton Faistauer** *Sketches and Designs for the Salzburg Festival Theater*. November 10, 1926.

30 **Christmas Exhibition** *Works by Viennese Artists*. December 4, 1926.

31 **Max Thalmann** January 7, 1927.

32 **The Unknown 19th Century in Works of Austrian Art** *Part II*. February 19, 1927. Paintings by F. Alt, F. Gauermann, A. Romako and others.

33 **Hans Thoma** *Memorial Exhibition*. April 9, 1927. Graphics.

34 **Leopold Hauer** April 30, 1927. Paintings, drawings and graphics.

35 **The Estate of Peter Altenberg** May 20, 1927. Photographs, inscribed postcards, manuscripts and diaries displayed with furnishings from the poet's room in the Graben Hotel.

36 **Karl Kotasz** July 5, 1927.

37 **Oskar Laske** *Watercolors of Vienna*. September 17, 1927.

38 **Philipp Friedrich Kaufmann** October 23, 1927.

39 **Second Sales Exhibition** *Willi Nowak and Fritz Waerndorfer*. December 1, 1927.

40 **Exhibition of Cacti** December 15, 1927.

41 **Wilhelm Thöny** January 14, 1928.

42 **Masterpieces of Austrian 19th-Century Painting** February 4, 1928. Held at the Hagenbund.

43 **Vincent van Gogh** February 18, 1928. Drawings and watercolors.

44 **Gustav Klimt and Bruno Lauterbach** March 29, 1928. Paintings and drawings by Klimt; paintings by Lauterbach.

45 **Georg Kirsta** April 19, 1928. Paintings, stage designs and drawings. In association with the Gesellschaft zur Förderung moderner Kunst in Vienna.

46 **Vincent van Gogh** May 5, 1928. Paintings.

47 **Arnold Clementschitsch** September 25, 1928. Paintings and graphics.

48 **Egon Schiele** *Memorial Exhibition on the Tenth Anniversary of his Death*. October 15, 1928. Paintings at the Hagenbund. Watercolors and drawings at the Neue Galerie (Bruno Grimschitz).

49 **Nicolaus Vadász** *Memorial Exhibition*. November 8, 1928. Oils, pastels, watercolors, drawings and graphics. Held at the Palais Palffy, Vienna.

50 **Georg Mayer-Marton and the Waldorf School** December 4, 1928.

51 **Max Slevogt** January 14, 1929. Drawings and graphics. Held at the Hagenbund.

52 **Third Sales Exhibition** February 11, 1929.

53 **Lovis Corinth** *Memorial Exhibition, Part II*. March 23, 1929. Paintings at the Hagenbund. Watercolors, drawings and graphics at the Neue Galerie.

54 **Georg Merkel** May 23, 1929. Paintings, watercolors and drawings (Hans Tietze).

55 **Fourth Sales Exhibition** July 10, 1929.

56 **Old Master Paintings** July 12, 1929.

57 **Russian Icons from the 16th to the 18th Centuries** September 30, 1929. Held at the Hagenbund and the Neue Galerie.

58 **Sergius Pauser** November 4, 1929.

59 **Opening of the Peter Altenberg Room** November 10, 1929.

60 **The Nude and the Portrait in Photography** December 6, 1929.

61 **Russian Christmas Sale** December 6, 1929. Held at the Hagenbund.

62 **Avant-Garde Photographs by Willy Riethof** January 4, 1930.

63 **Ferdinand Georg Waldmüller** January 25, 1930. Held at the Hagenbund.

64 **Carl Hofer** February 15, 1930.

65 **The Black Painter, Kalifala Sidibé, and the Crafts of South American Indians** March 15, 1930.

66 **Gerhart Frankl** May, 1930.

67 **Masters of Austrian Painting of the 19th and 20th Centuries** June 10, 1930.

68 **Alfred Hawel** September 4, 1930.

69 **Unknown Works by Egon Schiele** October 28, 1930.

70 **Vienna and the Vienna Woods** *One Hundred New Watercolors by Oskar Laske.* December 4, 1930.

71 **Russian Art of Today** October, 1930. Oils, watercolors, drawings, graphics and sculpture. Held at the Hagenbund.

72 **Karl Sterrer** January 3, 1931. Landscapes and portraits.

73 **European Sculpture** February 7, 1931. A. Archipenko, E. Barlach, E. Degas, P. Gauguin, M. Klinger, W. Lehmbruck, A. Maillol, C. Meunier, P. Picasso, A. Rodin, M. Rosso and others. Held at the Hagenbund.

74 **Auguste Renoir** March 17, 1931. Paintings, watercolors, graphics and sculpture.

75 **Alfred Kubin** April 22, 1931. Watercolors, drawings and lithographs (Alfred Kubin).

76 **Erich A. Lamm** May 16, 1931. Held at the Handelsmuseum.

77 **Of Art and Life in the Soviet Union** May 29, 1931.

78 **Johann Strauss** *Documentary Exhibition.* June 1931. Held at the Hagenbund (Fritz Lange).

79 **Austrian and German Art of Today** July 20, 1931.

80 **Richard Gerstl** *An Artist's Fate.* September 28, 1931. Oils and drawings. Subsequently shown at: Galerie Caspari, Munich (January–February 1932); Galerie Gurlitt, Berlin (June–July, 1932); Kölnischer Kunstverein, Cologne (November–December, 1932); Städtisches Suermondt Museum, Aachen (January 1933); Galerie Welz, Salzburg (May 1933).

81 **Five Painters from Vienna** November 10, 1931. L. Frank, H. Frank, F. Rojka, E. Wagner and watercolor portraits by W. Essenther.

82 **The Christmas Present** December 8, 1931. Including an unusual exhibition of Polish weavings and Hungarian folk art.

83 **Modern Austrian Painting** December 12, 1931. Held at the Hagenbund.

84 **Franz Naager** January 1, 1932.

85 **The Age in Pictures** *Historical Photographs of Seven Decades.* January 24, 1932.

86 **Poets who Paint and Painters who Write Poetry** February 18, 1932. Held at the Hagenbund.

87 **The Collection of Carl von Reininghaus** February 29, 1932. Held at the Hagenbund.

88 **The First Austrian Airmail Exhibition** March 19, 1932. In association with the Österreichischer Flugpostsammler Verein.

89 **A Spring Exhibition** April 14, 1932.

90 **Herbert Böckl** June 10, 1932. Watercolors and drawings. Also shown: *L'Arlésienne* by Vincent van Gogh.

91 **New Portraits by Alfred Hawel** *Viennese Personalities.* September 16, 1932.

92 **Oskar Kokoschka** October 22, 1932. Paintings, watercolors and drawings, 1927-1932.

93 **Aussee and the Salzkammergut** December 6, 1932. Paintings and watercolors by G. Ehrlich, E. Lang, O. Laske, F. Lerch and others.

94 **The Gliders of Robert Kronfeld** December 30, 1932. Organized by the Österreichischer Flugpostsammler Verein. Held at the Hagenbund.

95 **French Impressionism** February 11, 1933. P. Cézanne, G. Courbet, E. Degas, V. van Gogh, E. Manet, A. Renoir, H. de Toulouse-Lautrec and others.

96 **From the Vienna of Emperor Franz Josef I** *The Collection of Alfred Pick, Part I.* March 30, 1933.

97 **Fritz Jerusalem** April 25, 1933.

98 **Anton Faistauer, Gustav Klimt, Oskar Kokoschka and Egon Schiele** June, 1933.

99 **From Private Collections in Vienna** November 11, 1933. Works by R. von Alt and A. von Pettenkofen.

100 **Exhibition for Young Stamp Collectors** December 8, 1933.

101 **Franz Rederer** January 16, 1934.

102 **Ten Years Neue Galerie** *A Review.* March 20, 1934 (Otto Kallir).

103 **Hieronymus Löschenkohl** *From the Vienna of Emperor Josef II.* May 11, 1934.

104 **The History of World War I in Documents** June 23, 1934.

105 **Rudolf von Zeileissen** September 22, 1934.

106 **Adolf Winternitz** October 12, 1934.

107 **Hans Pilhs** *A New Painter.* November 16, 1934.

108 **Twenty Schilling Exhibition** January 21,

1935. Watercolors, drawings and graphics of significant 19th and 20th century artists.

109 **Italian Futurist Paintings of Air and Flight** February 21, 1935.

110 **Ten, Twenty, Thirty Schilling Exhibition** April 9, 1935.

111 **Graphic Exhibition** June 15, 1935. W. Kaufmann, C. Rabus, A. Steinhart and R. Wacker.

112 **Summer Exhibition** July, 1935.

113 **Viennese Memorabilia** *The Collection of Alfred Pick, Part II.* September 28, 1935.

114 **Salzburg and the Salzkammergut** *One Hundred Years Ago and Today.* October 9, 1935.

115 **Sven Hedin** December 9, 1935.

116 **Darwisch** *An Iranian Artist Visiting Vienna.* January 18, 1936.

117 **Georg Ehrlich and Otto Rudolf Schatz** February 12, 1936. New sculptures and studies by Ehrlich; watercolors by Schatz.

118 **Three Centuries of Peasant Painting** March 13, 1936 (Rudolf Kriss and Leopold Schmidt).

119 **Johanna Kubelik** May 12, 1936. In association with the Europäisches Jugendbündnis in Vienna.

120 **Film and Theater** *A Photo-Reportage by H. Casparius and Otto Kallir-Nirenstein.* June 3, 1936.

121 **Modern Austrian Art** June 13, 1936. L. H. Jungnickel, O. Kokoschka, A. Kubin, O. Laske, F. Lerch, G. Merkel, F. Wotruba and others. Held at the Lothringerstrasse Branch.

122 **Beth Zeeh** September 29, 1936. Paintings and watercolors.

123 **Sculptures by the Archduchess Ileana; From the Baroque to the Secession** October 10, 1936. Held at the Lothringerstrasse Branch.

124 **Anton Romako** November 14, 1936. Held at the Lothringerstrasse Branch.

125 **The History of World War I in Airplane Leaflets** November 20, 1936.

126 **Masterworks of European Graphics** December 7, 1936. H. Daumier, E. Degas, E. Delacroix, P. Gauguin, E. Manet, A. Rodin, J. M. Whistler and others.

127 **Max Liebermann** January 15, 1937. Paintings at the Lothringerstrasse Branch. A related exhibition of Liebermann's oil studies and drawings opened at the Neue Galerie, January 16, 1937 (combined catalogue).

128 **Adolf Winternitz** March 2, 1937. Held at the Lothringerstrasse Branch.

129 **Ferdinand Schmutzer** March 10, 1937. Paintings and drawings.

130 **Otto Rudolf Schatz** *Travel Sketches of New York.* April 20, 1937.

131 **Paintings from the 16th to the 20th Centuries** *From a Private Collection in Breslau.* May 31, 1937.

132 **From the Private Collection of A. Widakovich, Vienna** October 12, 1937.

133 **Important Paintings** November 29, 1937. F. von Amerling, T. Blau, H. Böckl, L. Corinth, A. Faistauer, G. Klimt, O. Kokoschka, M. Liebermann, A. Romako, F. G. Waldmüller and others.

134 **The Ender Family of Artists** February 14, 1938.

Exhibitions Organized by Dr. Vita Maria Künstler at the Neue Galerie, Vienna.

135 **The Austrian Baroque** November 15, 1938. A. F. Maulbertsch, P. Troger and others.

136 **From Private Collections in Vienna** February 12, 1939. A. von Pettenkofen, J. M. Ranftl, A. Romako and others.

137 **From Munich Ateliers** April 4, 1939. Watercolors, drawings and graphics of living artists.

138 **From Austrian Ateliers** June 1, 1939. Works of living artists.

139 **Christmas Exhibition** December 9, 1939.

140 **The Viennese Interior from the Empire until the Present** October 17, 1940.

141 **The Experience of Strange Lands in the 19th Century** October 3, 1941.

142 **Christmas Gifts for Friends of Art and Culture** December, 1941.

143 **Christmas Exhibition** November 12, 1942. Works by O. Gawell and U. Diederich-Schuh.

144 **Graphic Works of Painters from Danzig** December 16, 1942.

145 **Indestructible Vienna** July 17, 1945. Works by J. Dobrowsky, G. Frankl, O. Laske, S. Pauser and others.

146 **Gustav Klimt, Oskar Kokoschka and Egon Schiele** September 15, 1945. Watercolors, drawings and graphics. In association with the Österreichische Kulturvereinigung (Benno Fleischmann).

147 **G. Baszel and A. Sebela; Christmas Exhibition** November 30, 1945.

148 **Josef Danhauser on the 100th Anniversary of his Death** March 19, 1946. In association with the Österreichische Kulturvereinigung.

149 **Werner Scholz** May 10, 1946. Paintings and pastels.

150 **Richard Gerstl and Young Artists from Styria** June 22, 1946.

151 **Caroline Kubin and Gerhild Diesner** September 20, 1946. Oils.

152 **Gerhart Frankl** November 9, 1946. In association with the Institut für Wissenschaft und Kunst.

153 **An Artwork as a Gift** December 13, 1946.

154 **Johannes Behler and Paul Flora** March 5, 1947. Watercolors and drawings.

155 **The Art-Club of Austria** April 12, 1947.

156 **Two Viennese Artists at the Turn of the Century** *Peter Altenberg and Richard Gerstl.* June 7, 1947.

157 **Art from the Present, the Past and the Distant Past** July 29, 1947.

158 **Eugène Jettel and Rudolf Ribarz** *Austrian Impressionists.* October 4, 1947. Oils and drawings.

159 **Christmas for Art-Lovers** November 26, 1947. Works by W. Augustiner and K. Stark.

160 **Franz Barwig the Elder, Franz Barwig the Younger and Gustav Klimt** March 12, 1948. Sculptures and drawings by the Barwigs; drawings by Klimt.

161 **New Italian Art** May 22, 1948. Paintings, watercolors and graphics by members of the Italian Art-Club.

162 **Fritz Fröhlich and Max Groten** June 30, 1948. Paintings, watercolors and drawings.

163 **Exhibition of Divers Works** August 15, 1948.

164 **Twenty-Five Years Neue Galerie** *Egon Schiele.* October 20, 1948. A memorial exhibition on the 30th anniversary of Schiele's death. 55 oils (Vita Maria Künstler; Otto Kallir).

165 **Small, Good Art Works from the 19th and 20th Centuries** January 27, 1949. J. Alt, T. Blau, P. Flora, G. Klimt, A. Kubin, E. Schiele and others.

166 **The Graphic Work of Georges Rouault** April 2, 1949. Lithographs, etchings and woodcuts. In association with the Galerie St. Etienne, New York.

167 **Lovis Corinth** May 13, 1949. Paintings, drawings and graphics.

168 **Review of Twenty-Five Years** September 14, 1949.

169 **Walt Disney** October 28, 1949. Original celluloids from his films: *Bambi, Pinocchio, Fantasia, Dumbo,* etc. In association with the Galerie St. Etienne, New York.

170 **Gerhild Diesner and Paul Flora** January 14, 1950.

171 **Friedrich Gauermann** March 4, 1950.

172 **Sales Exhibition** May 18, 1950.

173 **Grandma Moses** June 13, 1950. Fifty oils. In association with the Galerie St. Etienne, New York, and under the auspices of the U.S. Information Service (Louis Bromfield; Otto Kallir).

174 **Alexander Calder** May 10, 1951. In association with the Art-Club.

Exhibitions Organized by Evamarie Kallir at the Neue Galerie, Vienna.

175 **Cuno Amiet** October 1953. Oils, watercolors and graphics. Sponsored by the Swiss Ambassador, and organized in association with the Galerie St. Etienne, New York (Hans Ankwicz-Kleehoven).

176 **Flower Paintings of Yesterday and Today** November 13, 1953.

177 **Christmas Exhibition** *Old and New Paintings on Glass.* December 1953 (Leopold Schmidt).

178 **The Picture and the Frame** February 4, 1954 (Gerhart Egger).

179 **Primitive Paintings from Haiti** March 12, 1954. In association with the Galerie St. Etienne, New York (Etta Becker Donner; Evamarie Kallir).

180 **Egon Schiele** March 12, 1954. Drawings.

181 **Josef Scharl** April 1954. In association with the Galerie St. Etienne, New York.

182 **Oskar Laske** May 10, 1954.

183 **Margret Bilger** May 10, 1954 (Karl Garzarolli).

184 **Der Kreis** June, 1954.

Exhibitions Organized by Karl Gerstmayer at the Neue Galerie, Vienna.

185 **Trude Waehner** January 13, 1955. Portraits and landscapes.

186 **Katharina Sallenbach** February 21, 1955.

187 **Karl Patko and Walter Steinberg** March 26, 1955. Paintings and graphics by Patko; abstract compositions by Steinberg.

188 **Angela Varga and Ida Varga** April 29, 1955. Oils, graphics and pottery by A. Varga; ceramic sculptures and vessels by I. Varga.

189 **Louis Maria Autzinger** *Inside the Workshop of a Tapestry Weaver.* June 3, 1955.

190 **Arta** June 3, 1955. Lithographs, etchings and woodcuts.

191 **G. E. Näs.** September 15, 1955. Pastels.

192 Rudolf Korunka October 12, 1955. Paintings and graphics.

193 Vienna, City and Landscape November 9, 1955.

194 The Greeting Card, Yesterday and Today January 8, 1956.

195 Works from Kokoschka's Lithography Class in Salzburg, 1955 January 12, 1956.

196 Chryssoula Zoyia February 6, 1956. Still lifes and landscapes.

197 Emerich Schaffran February 7, 1956. Paintings and graphics.

198 Maria Somogyi March 7, 1956.

199 Rosa Schafer April 4, 1956.

200 Ernst Paar May 4, 1956.

Exhibitions Organized by Dr. Otto Kallir at the Galerie St. Etienne, 50 Faubourg Saint-Honoré, Paris.

1 Austrian Art February, 1939. Including major paintings by F. G. Waldmüller, A. Romako, G. Klimt and O. Kokoschka.

2 Oskar Kokoschka March, 1939. Paintings and drawings.

3 Group Exhibition May, 1939. Paintings by L. Corinth, M. Liebermann and French artists of the 19th and 20th centuries; drawings by G. Klimt.

4 Jean Egger June, 1939. Paintings.

Exhibitions Organized by Dr. Otto Kallir at the Galerie St. Etienne, New York.

1 Austrian Masters November 13, 1939. Paintings by F. G. Waldmüller, R. Alt, P. Fendi, J. Kriehuber, A. von Pettenkofen, A. Romako and others. Also, old Viennese porcelains, miniatures and manuscripts of famous composers: Beethoven, Mozart, Schubert, Strauss and others. The Picture of the Month: *L'Arlésienne* by Vincent van Gogh.

2 Oskar Kokoschka† January 9, 1940. Drawings and oils.

3 H. W. Hannau *Metropolis, Photographic Studies of New York.* February 2, 1940.

4 French Masters of the 19th and 20th Centuries February 29, 1940. P. Cézanne, E. Manet, P. A. Renoir, A. Rodin, M. Utrillo, V. van Gogh and others. The Picture of the Month: *L'Homme aux bras croisés* by Paul Cézanne.

5 Wilhelm Thöny† April 3, 1940. Paintings and drawings.

6 Franz Lerch† May 1, 1940. Oils and watercolors.

7 American Abstract Art May 22, 1940. Arranged jointly by Stephan Lion and Otto Kallir. Oils and watercolors by J. Albers., S. Davis, L. Feininger, A. Gorky, J. Matulka, L. Moholy-Nagy, G. L. K. Morris, I. Rice Pereira, J. Xceron and others (George L. K. Morris).

8 Saved from Europe *Masterpieces of European Art.* Summer 1940. L. Corinth, G. Klimt, K. Kollwitz, M. Liebermann, P. Modersohn-Becker, M. Beckmann, E. Schiele and others. The Picture of the Month: *Self-Portrait* (1901) by Pablo Picasso.

9 What a Farm Wife Painted *Works by Mrs. Anna Mary Moses.**‡ October 9, 1940.

10 Georg Merkel† November 7, 1940. Oils and pastels.

11 Weavings by Navaho and Hopi Indians and Photos of Indians by Helen M. Post January 29, 1941.

12 Flowers from Old Vienna *18th and Early 19th Century Flower Painting.* May 7, 1941. F. Alt, M. M. Daffinger, J. Neugebauer, W. Tamm and others.

13 Betty Lane June 3, 1941. Oils and gouaches. First one-person show in New York.

14 Egon Schiele† November 7, 1941. Paintings and drawings.

15 Alfred Kubin *Master of Drawing.*† December 4, 1941. Drawings, watercolors and lithographs.

16 Bertha Trabich *Memorial Exhibition of a Russian-American Primitive.** March 25, 1942. The Picture-of-the-Month Room: 19th century Santos from New Mexico.

17 Honoré Daumier‡ April 29, 1942. Lithographs.

18 Documents which Relate History *Documents of Historical Importance and Landmarks of Human Development.* June 10, 1942.

19 Walt Disney Originals‡ September 23, 1942.

20 Abraham Levin November 4, 1942. Paintings.

21 Illuminated Gothic Woodcuts *Printed and Painted, 1471-1493.*‡ December 5, 1942.

22 Seymour Lipton* January 18, 1943. Sculpture.

23 Eugen Spiro† February 13, 1943. Paintings.

24 Oskar Kokoschka *Aspects of His Art*‡ March 31, 1943. Oils, watercolors and graphics, 1908–1938.

25 Josephine Joy *Paintings by an American Primitive.* May 3, 1943.

26 Lovis Corinth May 26, 1943. Oils, drawings and graphics.

27 Will Barnet September 29, 1943. Oils and graphics. First show of oil paintings.

28 Käthe Kollwitz *Part I.* November 3, 1943. Drawings, etchings, lithographs and woodcuts.

29 Walt Disney Cavalcade December 9, 1943.

30 Betty Lane January 11, 1944. Paintings.

31 Grandma Moses *Paintings by the Senior of the American Primitives.* February 9, 1944.

32 Lesser Ury *Memorial Exhibition.*† March 21, 1944. Oils, pastels and drawings.

33 Abraham Levin April 15, 1944. New paintings.

34 Juan De'Prey *Paintings by a Self-Taught Artist from Puerto Rico.** May 6, 1944.

35 Max Liebermann *Memorial Exhibition.*† June 9, 1944. Oils, pastels, drawings and etchings (Thomas Mann).

36 A Century of French Graphic Art *From Géricault to Picasso*‡. September 28, 1944.

37 Käthe Kollwitz *Part II.* October 26, 1944. Drawings, etchings, lithographs and woodcuts.

38 Grandma Moses *New Paintings.* December 5, 1944.

39 Eugen Spiro January 20, 1945. Oils, drawings and lithographs (Thomas Mann).

40 Vienna through Four Centuries March, 1945.

41 Max Liebermann *The Graphic Work.* April 18, 1945.

42 Fred E. Robertson *Paintings by an American Primitive.** June 13, 1945.

43 Käthe Kollwitz *Memorial Exhibition*‡. November 21, 1945.

44 Georges Rouault *The Graphic Work*‡. February 26, 1946.

45 Ladis W. Sabo *Paintings by a New Primitive Artist.** April 8, 1946.

46 Henri de Toulouse-Lautrec‡ May 17, 1946. Lithographs. The Picture of the Month: *Messalina* by Henri de Toulouse-Lautrec.

47 Eugen Spiro November 25, 1946. Oils and lithographs.

48 Mark Baum* January 11, 1947. Paintings.

49 Hugo Steiner-Prag† March 15, 1947. Paintings, drawings and graphics (Johannes Urzidil).

50 Lovis Corinth April 16, 1947. Paintings, drawings and graphics (Edward Alden Jewell).

51 Grandma Moses May 17, 1947. Paintings (Grandma Moses).

52 Käthe Kollwitz October 4, 1947.

53 Fritz von Unruh* November 10, 1947. Paintings (Fritz von Unruh).

54 Christmas Exhibition December 4, 1947.

55 Vally Wieselthier *Memorial Exhibition.*† January 10, 1948. Ceramic sculpture. Also shown: watercolors by Po-Powi-Da,* a San Ildefonso Indian.

56 Miriam Richman* February 7, 1948. Paintings.

57 Egon Schiele *Memorial Exhibition.* April 5,

1948. Oils, watercolors and drawings (Joseph von Sternberg).

58 **American Primitives** June 3, 1948. E. Hicks, J. Kane, J. Pickett and others.

59 **Käthe Kollwitz** *Masterworks*. October 18, 1948. (Käthe Kollwitz).

60 **Ten Years Grandma Moses** November 22, 1948 (Grandma Moses).

61 **Frans Masereel** January 13, 1949. Oils, drawings and woodcuts.

62 **Eugen Spiro** February 19, 1949. Oils and drawings.

63 **Oskar Kokoschka** March 30, 1949. Oils, drawings and lithographs.

64 **Gladys Wertheim Bachrach** May 24, 1949. Paintings.

65 **Autograph Exhibition** October 26, 1949.

66 **Tenth Anniversary Exhibition** *Part I*. November 30, 1949. Käthe Kollwitz.

67 **Anton Faistauer**† January 1, 1950. Oils, pastels, watercolors and drawings.

68 **Chiao Ssu-Tu*** February 18, 1950. Bamboo stick drawings and watercolors.

69 **Austrian Art of the 19th Century** *From Waldmüller to Klimt*. April 1, 1950 (Ernst H. Buschbeck).

70 **Tenth Anniversary Exhibition** *Part II*. May 11, 1950. Group show of works by Galerie St. Etienne artists.

71 **Oskar Laske** *Watercolors of Vienna and the Salzkammergut*.† October 14, 1950.

72 **Roswitha Bitterlich**† January 18, 1951. Oils, drawings and graphics.

73 **Grandma Moses** *Twenty-Five Masterpieces of Primitive Art*. March 17, 1951 (Allen Eaton).

74 **Drawings and Watercolors by Austrian Children** May 21, 1951.

75 **Käthe Kollwitz** October 25, 1951. Drawings and sculpture.

76 **I-Fa-Wei** *Watercolors of New York by a Chinese Artist.* December 1, 1951.

77 **Ten Years of New York Concert Impressions by Eugen Spiro; Four New Paintings by Fritz von Unruh** January 26, 1952.

78 **American Natural Painters** March 31, 1952. S. Blair, H. O. Kelly, I. Litwak, Grandma Moses, L. Sabo and others (Jean Lipman).

79 **Margret Bilger** May 10, 1952. Woodcuts. First one-person show in New York.

80 **Hasan Kaptan** *Paintings of a Ten-Year-Old Turkish Painter.* † October 29, 1952.

81 **Paintings on Glass** *Austrian Religious Folk Art of the 17th to 19th Centuries*. December 4, 1952.

82 **Streeter Blair** *American Primitive*. February 26, 1953. Paintings. First one-person show in New York.

83 **A Grandma Moses Album** *Recent Paintings, 1950-1953*. April 15, 1953.

84 **Lovis Corinth, Oskar Kokoschka and Egon Schiele** May 27, 1953. Oils, watercolors and drawings.

85 **Wilhelm Kaufmann** September 30, 1953. Oils and watercolors.

85a **Grandma Moses** October 21–24, 1953. On the occasion of the dedication of Grandma Moses' painting, *The Battle of Bennington*, to the Daughters of the American Revolution.

86 **Josef Scharl** November 11, 1953. Oils and drawings.

87 **Irma Rothstein** December 8, 1953. Sculpture.

88 **Einar Jolin**† January 14, 1954. Paintings.

89 **Cuno Amiet**† February 16, 1954. Oils, watercolors, drawings and graphics (Otto Kallir).

90 **Per Krogh**† April 2, 1954. A loan exhibition of paintings under the patronage of the Norwegian Embassy.

91 **James N. Rosenberg and Eugen Spiro** April 30, 1954. Pastels by Rosenberg; oils by Spiro.

92 **Isabel Case Borgatta and Josef Scharl** October 12, 1954. Sculptures by Borgatta; drawings and temperas by Scharl (Mark van Doren; Justus Bier).

93 **Oskar Kokoschka** November 29, 1954. Watercolors, drawings and lithographs.

94 **Masters of the 19th Century** January 18, 1955. Watercolors, drawings and graphics.

95 **Freddy Homburger** March 2, 1955. Watercolors (Morris L. Ernst).

96 **Erich Heckel**† March 29, 1955. Watercolors.

97 **Juan De'Prey** April 19, 1955. Oils and drawings.

98 **As I See Myself** One Hundred Paintings by American School Children. May 20, 1955. Subsequently circulated in the U.S. by the Smithsonian Institution.

99 **A Tribute to Grandma Moses** November 28, 1955. A loan exhibition of paintings by Grandma Moses assembled in observance of the artist's 95th birthday. Held at the IBM Gallery (Thomas J. Watson and Grandma Moses).

100 **Käthe Kollwitz** April 16, 1956. Drawings and rare prints.

101 **Irma Rothstein** May 19, 1956. Sculptures (Curt Sachs).

102 **Josef Scharl** *Memorial Exhibition*. November 17, 1956. Oils. (Albert Einstein).

103 **Egon Schiele** January 21, 1957. Watercolors and drawings (Otto Benesch).

104 **Franz Lerch** March 2, 1957. Oils.

105 **Alfred Kubin** April 3, 1957. Oils, watercolors and drawings (Otto Kallir).

106 **Grandma Moses** May 6, 1957. New York showing of an exhibition of paintings presented in Europe during 1955–1957 (Otto Kallir; Hubertus, Prince zu Löwenstein).

107 **The Four Seasons** *One Hundred Paintings by American School Children*. June 11, 1957. Subsequently circulated in the U.S. and abroad by the Smithsonian Institution.

108 **Margret Bilger** October 22, 1957. Watercolors, drawings and woodcuts.

109 **Jules Lefranc and Dominique Lagru** *Two French Primitives*. November 18, 1957. Paintings. First American showing (Jean Cassou; Anatole Jakovsky).

110 **The Great Tradition in American Painting** *American Primitive Art*. January 20, 1958.

111 **Paula Modersohn-Becker**† March 15, 1958. Oils, drawings and etchings.

112 **Two Unknown American Expressionists** *Paintings by Marvin Meisels and Martin Pajeck*. April 28, 1958. First showing.

113 **Village Life in Guatemala** *Paintings by Andres Curuchich*. June 3, 1958. First one-person show in New York.

114 **Oskar Kokoschka** October 28, 1958. Watercolors, drawings and lithographs.

115 **Käthe Kollwitz** January 12, 1959. Drawings, posters and rare prints.

116 **Gustav Klimt**† April 1, 1959. Oils and drawings (Otto Kallir).

117 **Marvin Meisels and Martin Pajeck** May, 1959. Oils and drawings.

118 **Our Town** *One Hundred Paintings by American School Children*. May 23, 1959. Subsequently circulated in the U.S. by the Smithsonian Institution.

119 **European and American Expressionists** September 22, 1959. L. Corinth, G. Klimt, O. Kokoschka, K. Kollwitz, M. Meisels, P. Modersohn-Becker, M. Pajeck, E. Schiele and others.

120 **Josef Scharl** *Last Paintings and Drawings*. November 11, 1959.

121 **Käthe Kollwitz** December 14, 1959. Thirteen

bronzes and twenty drawings. First comprehensive show in the U.S. of the artist's sculpture.

122 **Eugen Spiro** February 6, 1960. Recent paintings.

123 **Martin Pajeck** February 29, 1960. Oils and drawings (Edith Hoffmann).

124 **Watercolors and Drawings by Austrian Artists from the Dial Collection** May 2, 1960. G. Klimt, O. Kokoschka, A. Kubin, E. Schiele and others. Lent by the Worcester Art Museum.

125 **My Life's History** *Paintings by Grandma Moses*. September 12, 1960. Held at the IBM Gallery in observance of the artist's 100th birthday. Subsequently circulated for one year by the Smithsonian Institution and presented at museums in the United States. Shown from 1962 to 1964 in fifteen European museums in Austria, France, Germany, the Scandinavian countries, and the Soviet Union.

126 **Egon Schiele** November 15, 1960. Comprehensive exhibition of oils, watercolors, drawings and prints arranged in cooperation with the Institute of Contemporary Art, Boston. After the showings in Boston and New York, the exhibition was presented by the J. B. Speed Museum, Louisville, the Carnegie Institute, Pittsburgh, and the Minneapolis Institute of Arts (Thomas M. Messer; Otto Kallir).

127 **Marvin Meisels** January 23, 1961. Oils.

128 **Gustav Klimt, Egon Schiele, Oskar Kokoschka and Alfred Kubin** March 14, 1961. Oils and drawings.

129 **Raimonds Staprans** April 17, 1961. Oils. First one-person show in New York.

130 **My Friends** *Fourth Biennial of Pictures by American School Children*. May 27, 1961. Subsequently circulated in the U.S. by the Smithsonian Institution.

131 **Grandma Moses** September 7, 1961. Paintings which illustrate *The Grandma Moses Story Book*, in honor of the artist's 101st birthday.

132 **Käthe Kollwitz** November 11, 1961. Drawings and rare prints.

133 **Paintings by Expressionists** January 27, 1962. L. Corinth, R. Gerstl, P. Modersohn-Becker, E. Munch. E. Nolde, M. Pechstein, E. Schiele and others.

134 **Martin Pajeck** February 24, 1962. Paintings.

135 **Ernst Barlach** March 23, 1962. Sculptures and drawings. (Alfred Werner).

136 **Group Show** October 15, 1962. Drawings by G. Klimt, O. Kokoschka, A. Kubin and E. Schiele; lithographs by O. Kokoschka, K. Kollwitz and E. Schiele.

137 **Grandma Moses** *Memorial Exhibition*. November 26, 1962. Paintings (Otto Kallir).

138 **French Impressionists** March 8, 1963. Watercolors, drawings, etchings and lithographs.

139 **Joe Henry** *Watercolors of Vermont*. May 1, 1963. First one-person show in New York.

140 **Panorama of Yugoslav Primitive Art** October 21, 1963. Paintings and sculpture. Organized in association with the Yugoslav Academy of Arts and Sciences, Zagreb. First American showing (Alexandra Kreid).

141 **Joseph Rifesser** December 3, 1963. Sculptures in wood and bronze (Otto Kallir).

142 **Austrian Expressionists** January 6, 1964. Watercolors, drawings and prints by R. Gerstl, G. Klimt, O. Kokoschka, A. Kubin, O. Laske, E. Schiele and others. Subsequently shown at: Sarasota Art Association, Sarasota, Florida (February 2–14, 1964); and the Fort Worth Art Center, Fort Worth, Texas (March, 1964) (Otto Kallir).

143 **B. F. Dolbin** *Drawings of an Epoch*. March 3, 1964.

144 **Eugen Spiro** April 4, 1964. Oils, drawings and lithographs. On the occasion of the artist's 90th birthday (Eugen Spiro).

145 **Werner Berg, Jane Muus and Mura Dehn** May 5, 1964. Woodcuts by Berg, woodcuts and etchings by Muus and "tapestries in stone" by Dehn. First American showing.

146 **Mary Urban** June 9, 1964. Oils (Otto Kallir).

147 **25th Anniversary Exhibition** *Part I*. October 17, 1964. L. Corinth, R. Gerstl, G. Klimt, O. Kokoschka, A. Kubin, E. Schiele and others (Otto Kallir).

148 **25th Anniversary Exhibition** *Part II*. November 21, 1964. Austrian and New Mexican religious folk art, works by Yugoslav and French primitives, Grandma Moses and others (Otto Kallir).

149 **Egon Schiele** *Watercolors and Drawings from American Collections*. March 1, 1965 (Thomas M. Messer).

150 **Käthe Kollwitz** May, 1965. Drawings.

151 **Oskar Laske** October 25, 1965. Oils and graphics (Otto Kallir).

152 **The Wiener Werkstätte** November 16, 1966. *Objets d'art* by J. Hoffman, D. Peche and others; paintings, drawings and graphics by G. Klimt, O. Kokoschka, E. Schiele, L. H. Jungnickel and others.

153 **Gustav Klimt** February 4, 1967. Drawings.

154 **Karl Stark**† April 5, 1967. Oils and gouaches.

155 **Abraham Levin** September 26, 1967. Oils and gouaches (Otto Kallir).

156 **Käthe Kollwitz** *In the Cause of Hum* October 23, 1967. In commemoration of the birthday of the artist. Drawings, etchings, li raphs and woodcuts (Otto Kallir).

157 **Alfred Kubin** January 30, 1968. Gouac. watercolors, drawings and graphics.

158 **Yugoslav Primitive Art** April 30, 1968. Gazi, I. Generalic, I. Rabuzin and others.

159 **Egon Schiele** *Memorial Exhibition*. Octo 31, 1968. In commemoration of the 50th anniversary of the artist's death. Watercolors and draw ings (Otto Benesch; Otto Kallir).

160 **Austrian Art of the 20th Century** March 2 1969. G. Klimt, M. Kurzweil, O. Laske, E. Schiele K. Stark and others.

161 **Friedrich Hundertwasser** May 6, 1969. Paint ings. Organized by the University Art Museum University of California, Berkeley (Herschel B. Chipp and Brenda Richardson; Jean Aberbach; Friedrich Hundertwasser).

162 **Gustav Klimt** March 20, 1970. Drawings (Gustav Glück; Fritz Novotny).

163 **Egon Schiele** *The Graphic Work*. October 19 1970. Material assembled in the course of research for Otto Kallir's book, *Egon Schiele: The Graphic Work*, published in 1970.

164 **Käthe Kollwitz** February 3, 1971. Drawings and rare prints.

165 **Branko Paradis*** December 1, 1971. A new Yugoslav primitive painter and a collection of works by E. Fejes, I. Generalic and I. Rabuzin.

166 **Georges Rouault and Frans Masereel** April 29, 1972. Etchings and lithographs by Rouault; watercolors, drawings and woodcuts by Masereel.

167 **Martin Pajeck** January 27, 1976. Paintings.

168 **Neue Galerie—Galerie St. Etienne** *A Documentary Exhibition*. May, 1976.

168a **Käthe Kollwitz** December 1, 1976. Held at Kennedy Galleries, New York, in association with the Galerie St. Etienne. Drawings and graphics (Otto Kallir; Rudolf G. Wunderlich).

169 **American Primitive Art** November 22, 1977. Embroidered samplers; religious art of New Mexico; paintings by E. Hicks, A. Kingsley, Grandma Moses, J. Pickett, H. Pippin and others (Otto Kallir).

* First one-person exhibition

† First one-person exhibition in the United States

‡ A modified version of this exhibition traveled to museums, universities and art associations across the United States.

7.27.92 MIDWEST 21.28 5.16.09